Contents

About the Author

Riley Arthur is a National Geographic Explorer and Fulbright Fellow. Her work has been published in *The New York Times, The Guardian, Der Spiegel, National Geographic, HuffPost, The Australian Financial Review,* and more. She has been interviewed for audio and video segments by a number of media outlets, including BBC News, BBC Radio, NowThis News, PIX11 News, and Brooklyn Free Radio. Arthur has led photography workshops in London, Prague, Maui, Colorado, and Detroit.

She has presented at conferences in Kyrgyzstan, Hawaii, and the UK. In addition to two Bachelor of Arts degrees from Southern Oregon University and a Master's degree in Visual Journalism from the University of Central Lancashire (UK), she's completed artist residencies in the Czech Republic, Estonia, Lithuania, and the UK. Her photographs have been exhibited in juried shows in eight countries and are a part of the permanent collections of eight museums and archives.

Arthur is best known for her work documenting New York City diners and its associated Instagram account @dinersofnyc. Born and raised in American Samoa, she currently resides in Detroit, Michigan, with her husband, Patrick, and closets full of photo gear.

To see more of her work, visit www.rileyarthur.com and follow her on Twitter @rileysart and Instagram @dinersofNYC.

WIRED

WIRED
FIRST 40.7

WIRED
CHICAGO

Phone Photography for Everybody
iPhone Photojournalism Techniques

PAUL'S DAUGHTER

**Create
Pro Quality
Images**

Riley Arthur

*National Geographic Explorer,
award-winning photographer & Fulbright scholar*

Dedication

To my husband, Patrick, whose continued support has been the wind at my back, propelling me onward through this and many projects prior.

Published by:
Amherst Media, Inc.
PO BOX 538
Buffalo, NY 14213
www.AmherstMedia.com

Publisher: Craig Alesse
Associate Publisher: Katie Kiss
Senior Editor/Production Manager: Barbara A. Lynch-Johnt
Senior Contributing Editor: Michelle Perkins
Editor: Beth Alesse
Acquisitions Editor: Harvey Goldstein
Editorial Assistance from: Carey A. Miller, Roy Bakos, Jen Sexton-Riley, Rebecca Rudell
Business Manager: Sarah Loder
Marketing Associate: Tonya Flickinger

ISBN-13: 978-1-68203-461-3
Library of Congress Control Number: 2020934902
Printed in the United States of America
10 9 8 7 6 5 4 3 2 1

AUTHOR YOUR PHONE PHOTOGRAPHY BOOK WITH AMHERST MEDIA

Are you an accomplished phone photographer? Publish your print book with Amherst Media and share your images worldwide. Our experienced team makes it easy and rewarding for each book sold and at no cost to you. Email submissions: craigalesse@gmail.com.

www.facebook.com/AmherstMediaInc
www.youtube.com/AmherstMedia
www.twitter.com/AmherstMedia
www.instagram.com/amherstmediaphotobooks

Introduction

I was attracted to photojournalism by an urge to tell stories outside of commercial photography. In my first years as a photographer, I initially gravitated toward fashion and theater photography while interning with the Oregon Shakespeare Festival. I quickly found I was much more drawn to documenting the things happening off stage than those on. In my first gigs shooting events, I was always more interested in photographing backstage, behind the curtain; illuminating a world of creators, cooks, set builders, and actors and musicians who weren't wearing the masks of their public personas. Like many young creatives, I wanted to make art that mattered. So it wasn't long before I began working on my first long-term photography project documenting systemic human rights violations with funding from Fulbright and *National Geographic*. Throughout the project, I always had my trusty iPhone 3, which I frequently took pictures with, though its quality at the time wasn't anywhere near my Canon 5D Mark III.

Having first ventured into the workforce in 2009, I'd found that much of the money available for and interest in hiring photographers had dried up in a rocky economy. Five years into my career, I went back to school in England for a master's degree in Visual Journalism. I was surprised to find how much phone photography was encouraged there.

Heading back into journalism post-master's in 2015, I went straight into an industry saturated by veteran talent, many of whom struggled to find steady work. Most of my colleagues, both older and younger, seemed to perpetually bounce around from one job to another, always fearful of layoffs. I quickly shifted from a newsroom to a tech company that creates editorial content, where I've found greater industry stability for creatives than in traditional journalism. In my current role at Red Ventures, I manage photo operations for Bankrate and The Points Guy, and often use my iPhone as part of my workflow.

In 2013, *The Chicago Sun-Times* laid off its 28-person full-time photo department and trained its reporters in iPhone photography, making it the first major print publication of its scale to do so. Among the esteemed photojournalists laid off by the *Sun-Times* was

Pulitzer Prize–winning photographer John H. White. This dramatic move made waves across the industry, and the initial iPhone images produced by reporters were heavily scrutinized. These reporters were using iPhone 5s at the time.

In the seven years since the *Sun-Times* shake up, and as of the publication of this book, twelve iPhone models have been released. Smartphone photography's overall quality has improved dramatically in a few short years. The use of these images has shifted from snapshots of family and selfies, to serious art photography and newsworthy images that have a gravitational impact on the digital media landscape.

Today's smartphone imaging quality is almost comparable to professional-grade DSLRs. Angling to win over consumers, smartphone cameras have been at the forefront of recent updates and releases from manufacturers like Apple, Samsung, and Google. Companies recognize the power a better-quality camera has in purchasing decisions. Converting customers to their product can result in a lifetime of future consumer loyalty, if lucky. The camera might be the most important feature of a smartphone today.

Apple has continued to position the iPhone at the forefront of the industry,

not just in photography, but also in filmmaking. Recent years have seen the release of feature-length films shot on iPhones, such as Sean Baker's 2015 *Tangerine* (shot on the 5S) and Academy Award–winner Steven Soderbergh's 2018 *Unsane* (shot on the iPhone 7 Plus). Video clips shot on smartphones regularly end up on the news, talk shows, and as popular viral content spread across social media. Authenticity drives the success of user-generated content. Today, most of us have a smartphone with a camera in our pocket at all times, and in an instant, we can shoot the next viral sensation. Smartphones have democratized the industry, giving everyone the ability to become a photojournalist.

Smartphones even the playing field for photographers and amateurs alike. Digital media and the 24-hour news cycle have ushered in a constant need for more content. The quality of images makes a big impact in driving digital clicks. It's difficult to say whether iPhones and other smartphones will ever completely eliminate the need for photo departments, or full-frame cameras, but they have gained prominence in the field and show no signs of slowing down.

I regularly use my iPhone in my day job as a photo manager, my freelance

photography business, and my personal work. Pictures I've taken on my iPhone have now been shown in galleries around the world. Over the last few years, I've worked on a project documenting New York City diners. The project has a growing Instagram following, has been covered in many of the most prestigious publications around the world, and wouldn't be possible without my iPhone.

Knowing how to fully utilize all the features of your iPhone and some of the best photo apps available will improve your photography skills as a whole and make you and your work more marketable. We have the opportunity to embrace an emerging technology, perfect its use, and take some incredible photographs without hauling around a ton of heavy (and expensive) equipment. Whether you are a digital native or less comfortable with your iPhone, you can learn how to master its settings and take your best-ever images on your iPhone.

This book is a tool for people who want to grow their iPhone photojournalism abilities. You may be a photographer looking to learn how to better use the new phone model. You may be an amateur or hobbyist looking to expand your skill set. You may be a journalist who is taking photos for assignment on your own phone. You might have very little experience in photography, and a desire to learn more. Perhaps you want to bring in some income selling your smartphone photography. Maybe you are a photographer looking to scale back on heavy gear. You might already have robust smartphone photo skills, but want to shoot more like a professional. You might be a student or recent graduate launching your career and needing to know how to use your phone for editorial, commercial, or lifestyle photography. Whatever your reasons for purchasing this book, whatever stage you may be at as a smartphone photojournalist, from beginner to pro, this book has got you covered, offering useful and actionable tips and the tools necessary to build your confidence in your smartphone photojournalism capabilities.

Now, get your phone charging. You'll want a full battery to start!

> **"Whether you are a digital native or less comfortable with your iPhone, you can learn how to master its settings and take your best-ever images on your iPhone."**

1. The Fundamentals

Preparation

When using your iPhone as your primary camera, it's important to bring everything you'll need for the day. While many of these things can be purchased while on a shoot, you may not have time.

Here are some items you may want to pack when shooting in the field:

- a notebook and writing instrument to take notes
- fully-charged portable battery pack or power bank and a charging cable
- tripod or Gorilla pod

- external lenses
- two Ziploc bags for weatherproofing
- water bottle
- microfiber cloth
- comfortable, event-appropriate shoes
- lightweight jacket

Orientation

A traditional camera is built to be held horizontally, and the default frame orientation is horizontal. iPhones, on the other hand, are optimized for vertical use. This is why so many iPhone photos are verticals. Taking horizontal images on an iPhone can be slightly more cumbersome, and depending on the size of your phone, might require two hands.

Most photos published in newspapers, online media, and magazines are horizontal, so consider this when shooting on assignment. It is always good practice to take a combination of both horizontal and vertical images, unless your editor requested a specific shot.

Ask yourself which orientation will make the strongest composition; don't default to vertical or horizontal. The shooting distance and crop will also

left. Gather the requisite accessories before heading out to shoot.

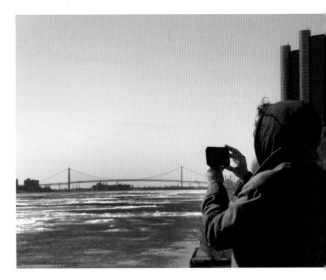

impact this decision. Portraits can work horizontally or vertically—and so can landscapes, if photographed effectively.

Ratios

The default image ratio for photos on an iPhone is 4:3. This translates to 4 inches of width for every 3 inches of height. This was the aspect ratio of the majority of films released before 1950. It is also the aspect ratio television used for most of the 20th century. The 16:9 ratio is a wide-screen format and is preferred by filmmakers. Therefore, it is fitting that the default aspect ratio for video on recent iPhone models is 16:9.

To change the ratio before shooting, swipe up on the screen and select 4:3; you will then see the three ratio options available: square (1:1), 4:3, and 16:9. Apple offers an expanded number of ratios in Edit mode after you've taken the image or video footage, including 10:8, 7:5, 5:3, 3:2, and freeform, which allows users to crop to the desired dimensions. To access these options, click Edit, then select the rotating icon. At the top, you'll find the Ratio icon; it looks like boxes within boxes. Click on this icon, and you'll have a variety of ratios to choose from.

Apps like Pro Camera and Lomograph offer additional shooting ratios, including 2:3 and 5:4.

Choose the best ratio to suit your needs. If you aren't sure which image ratio is right for each use, here is a little guidance:

The 3:2 ratio is favored by many because it is the closest to the golden ratio (see page 26). It is also the aspect ratio of 35mm film. Thus, it was the most common format for photojournalists for more than 60 years, prior to the advent of digital photography. 3:2 is a great selection if making prints. It's also the ratio of the 4x6-inch print size.

The 4:3 ratio is the standard ratio of computer monitors and screens, which is likely why Apple chose it as the default. It is also the preferred ratio for digital advertising and ad agencies.

The 1:1 ratio, a common size for traditional medium-format cameras, is the

this page. Here is the difference in the same framing with each ratio. The first image is a 4:3 ratio; the second image is 16:9, and the third is a 1:1 (square) ratio.

preferred ratio of the social media age, popularized by Instagram and other platforms.

The 16:9 ratio gives images a widescreen, cinematic look. It's the standard ratio for HDTV and motion pictures. It is most commonly used for shooting video, though it can be used to produce some incredible still photography.

The 5:4 ratio is the ratio of 8x10 and 16x20 prints. If you intend to print in those sizes and don't wish to crop the edges, use an app to shoot in that ratio.

The 7:5 ratio is the ratio of the print size 5x7. It is not frequently used in digital photography.

10:8 is not a commonly used ratio.

On-Camera Lenses

iPhone photographers have one to three built-in lenses on their camera, depending on the model. The iPhone 12 has a wide-angle and an ultra-wide-angle lens; the iPhone 12 Pro and Pro Max have those lenses, plus a telephoto lens. The iPhone SE has a single rear lens that's similar to the lens on the iPhone 8.

If you are using an iPhone with multiple lenses, you will see your lens choices above the shutter button when your Camera app is open. The app will default to the wide-angle (1x) lens. To select a different lens, click one of the other numbers.

Using the right lens is critical to getting the shot you want, and understanding what each lens does can help you make a more informed decision.

iPhones have two cameras: the rear camera, which faces out, and the front camera, which faces the iPhone user, best known for its ability to take selfies. These cameras are not created equal. Despite having True-Depth technology, which has drastically improved the iPhone's front-facing camera, it currently has a limited range and produces lower-quality images than the rear-facing camera. I recommend that you shoot with the rear-facing camera whenever possible.

Aperture & F-Stop

The aperture is the lens opening that allows light to enter the camera. The size of the aperture is measured in f-stops. Changing the f-stop, or aperture, brings

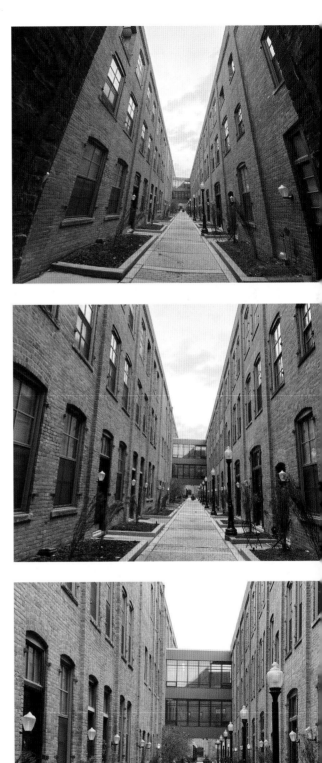

this page. **Images made with the iPhone 12 Pro's wide-angle lens (top), ultra-wide-angle lens (center), and telephoto lens (bottom).**

These images were taken at the same angle and from the same distance. Each lens produced a very different shot. The ultra-wide lens produced a warped perspective, as compared to the wide-angle lens. The telephoto lens flattened, or compressed, the elements in the photo.

in more or less light, which alters the range of focus. A lower f-stop produces a shorter depth of field (the area of the image, from front to back, that is in focus), while a higher f-stop produces a wider depth of field.

On the iPhone 12 and newer models, each of the lenses has a designated f-stop. The primary wide-angle lens is set at f/1.8, the ultra-wide at f/2.4, and the telephoto lens at f/2.0. Using Portrait mode will allow you to select other apertures. To do so, click on the lowercase "f" in the top-right corner and use the slider.

Several third-party camera apps, like Focos, offer the ability to adjust the f-stop prior to taking the photograph, providing the user with a broader focal range.

below. **Here are examples of shooting in Portrait mode with a narrow, medium, and wide aperture. The image shot at f/1.4 (left) shows the point of focus from the head to the knees, with everything else blurred. This is a great option for blurring distracting elements. The second image (center) was made with a slightly wider aperture, f/5.0. The subject and the background are in focus, and the foreground is the sharpest. The third image (right) was shot at f/13. Everything in the frame is in crisp focus.**

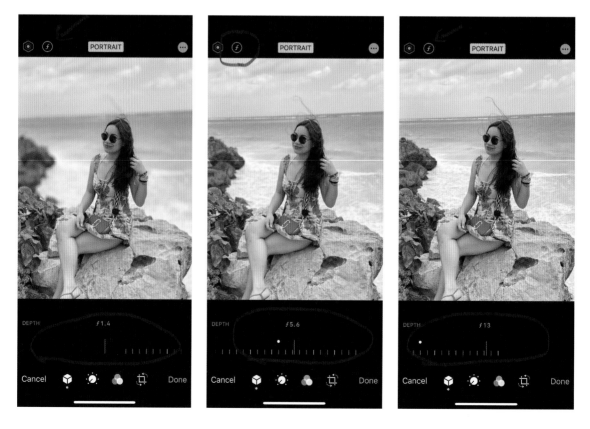

Changing the aperture can be an effective way to draw focus to key parts of the image. It's an important tool that will allow you to shape the way the photo looks.

Shutter Speed & ISO

During the film photography era, there was an ISO number printed on each box of film. The lower the number, the less sensitive the film was to light. On bright, sunny days, ISO 100 was a good choice. In scenes with progressively lower light, photographers would choose a film with a higher ISO.

In digital photography, the ISO number describes the sensitivity of the camera's sensor. The lower the number, the less light is recorded, but the clearer the pixels; the higher the ISO number, the more light is captured, but with more "noise." The key is to find the sweet spot that provides enough light without compromising image quality.

The iPhone is equipped with a large sensor, which is ideal, as it allows for increased resolution and overall quality when compared to smaller sensors.

Some apps allow you to set the ISO manually. In that case, an ISO of 100–400 would be appropriate for a sunny day outdoors. For dark indoor spaces, you may need an ISO of 800–3200. For low-light scenarios, you can also utilize Night mode, which sets the ISO automatically (see page 40).

Shutter speed is the span of time that the image sensor is exposed to light to create an image. "Long exposure" is another term for a slow shutter speed; "short exposure" refers to a fast shutter speed.

In the Camera app, the shutter speed is linked to the ISO, and both are set automatically. For well-lit compositions, the ISO defaults to a low setting, starting at ISO 25, and a fast shutter speed of up to $^1/_{8000}$. However, in unevenly lit or low-light conditions, the ISO automatically increases and the shutter speed slows down. This is not optimal, as the Camera app does not allow users to change the shutter speed. The Camera app doesn't display live exposure data, so it's not always clear before taking an image what the ISO or shutter speed will be, or if the shutter speed will be fast enough for what you are shooting.

Pro tip: Always use a tripod for long exposures to stabilize the camera and prevent blur.

Framing

Framing is the art of using the visual elements in the scene to create a frame within the frame and draw the eye to the center of interest. It is one of the

above. A fast shutter speed will freeze a moving subject and help you avoid blur.

right. Use a third-party app like Camera+ 2 to control your camera's exposure settings.

most important principles of photography and can ultimately be the defining element that differentiates a strong image from a weak one.

Take a moment to study your screen to ensure you don't awkwardly frame a subject. Also, avoid causing a sense of decapitation or the cropping of limbs. When shooting portraits, natural places to frame (and thereby crop) a shot are at the collarbone, elbows, hips, and fingertips. Framing at the subject's chin, wrists, ankles, or knees can lead to awkward compositions.

Consider the elements around you when you take an image. Are there interesting elements that can be included in

the frame that will help to tell the story? If so, choose the best ratio or move farther or closer to incorporate them in the scene. Are there distracting elements that you could exclude by shifting the camera? Would the image be stronger if taken at a different angle? Does the subject fill the frame? Will the viewer's eye be naturally drawn to the subject? Ask yourself these questions, then adjust accordingly.

In photojournalism, you will often have little control over your environment. Yet, even when covering newsworthy events, which may include fast action, do not overlook the importance of taking a couple seconds to frame

your shot. Hold your camera firmly or use a gimbal or tripod to avoid shake when necessary. Also, consider the Rule of Thirds (see page 25).

Ensuring the framing is correct in-camera prior to taking the photo prevents the need to crop the image later. iPhone photos are smaller than DSLR images, so excessive cropping can leave you with small, low-quality image files.

Once you master the art of framing, you may begin to experience life in rectangular frames—moments that are waiting to be captured in an image!

Pro tip: Consider the full frame. Don't neglect the foreground or background.

Filling the Frame

After framing, snap a photograph and look at it objectively. Are there any distracting elements? Is there dead space? Is there too much sky or ground? If so, you may not be adequately filling the frame.

In the words of legendary photographer Robert Capa, "If your pictures

below. **Careful framing is key to a successful image.**

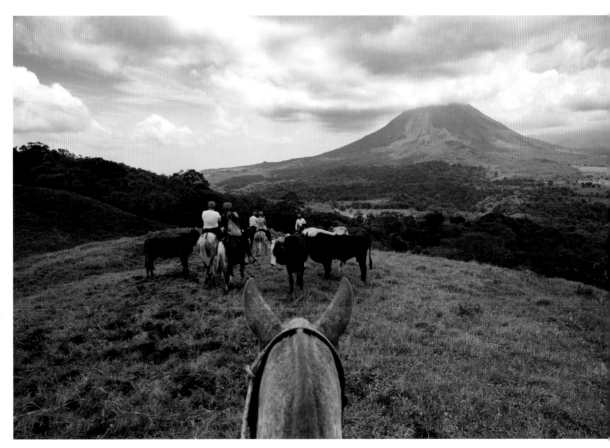

this page. **When framing your subject, consider your lens choice, ratio, and proximity to the subject to ensure that all important elements appear in the frame and distracting elements are excluded.**

aren't good enough, you aren't close enough." The in-camera zoom on the iPhone has improved greatly, but it's no substitute for moving closer to your subject. Getting closer to your subject can avoid confusion over the focal point of the image, too. By making your subject larger, you draw more attention to it.

Study the frame edges. If there is unnecessary space, move in closer or pick a different lens. In contrast, if you

are intentionally seeking wide-angle shots, step back.

Cropping

One key difference between editing iPhone images and digital images taken with a DSLR is the crop. Smartphone photos are usually cropped for social media use, most commonly into a square to suit Instagram's format. Digital images taken on a DSLR are typically cropped to trim excess or empty space. The key difference is that one edit is made with a specific use of the image in mind, while the

top and bottom. In the wide-angle shot, the mom and daughter are the point of focus, but they appear small in the frame. Cropping helps to draw attention to the pair, but cropping an iPhone image this tight creates pixelation, which is especially noticeable along the edges of the pair.

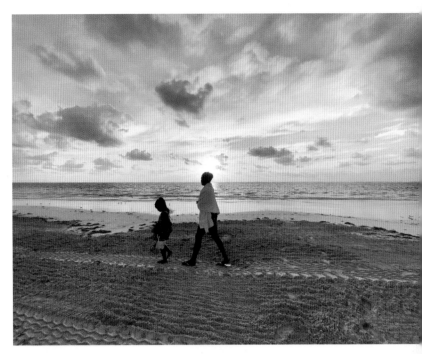

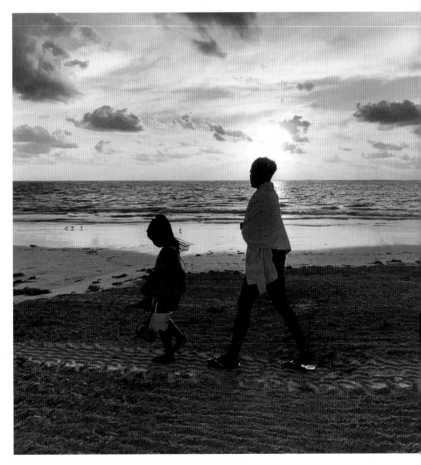

above. **The auto-focus capabilities of an iPhone are excellent, and apps like Pro Camera can improve upon the native app.**

other is made to improve the overall composition of the photograph.

iPhone images offer better image resolution than ever, but excessive cropping is still discouraged because it can result in a pixelated image. If cropping, consider the composition and the intended use. If shooting for Instagram, consider shooting in the square 1:1 ratio rather than cropping.

Focus

Each image you capture should have a point of focus, but not all images need to have the focal point in the center of the frame. Consider the compositional balance types and what story you're telling with the image. To ensure your camera is focusing where you need it to, press on the screen and select the focus. To lock in focus, press on the area of the image that should be most sharp until the AE/AF Lock pops up on the screen. Note that the iPhone camera will often automatically focus on human faces, but not always on objects.

Compositional Balance

The eye seeks balance in order to understand what it sees. For strong

compositions, strive for visual harmony between the key areas of focus.

There are four main types of balance in art and design: symmetrical, asymmetrical, radial, and mosaic balance. When using any one of these types of balance, your image will be more

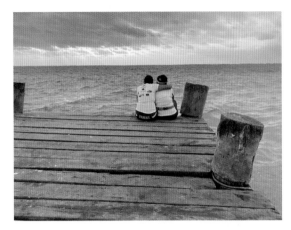

this page. The skier is perfectly flanked by a phone booth and gondola of similar shape, size, and color in a great example of symmetrical balance. As the person is exactly between the other two elements, this is also an example of a decisive moment (see pages 30–31).

The image of the pair sitting on the edge of a dock is also symmetrically balanced, with the couple being of similar size, as well as the dock pillars in the foreground.

The photo of the dog walkers is an example of asymmetrical balance, showing the two women and dogs on slightly different planes. Being closer to the camera, the woman in blue appears larger in the frame, even though as viewers, we understand the women to be of similar heights. This effect is repeated in the two dogs.

The final photograph is an example of asymmetrical balance. The two sunbathers alone would be an example of symmetrical balance, but the mom and son in the background, much smaller in the frame, create asymmetrical balance.

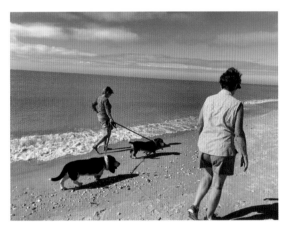

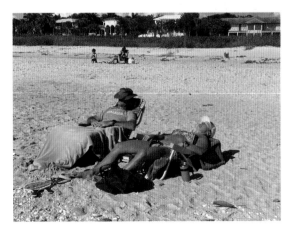

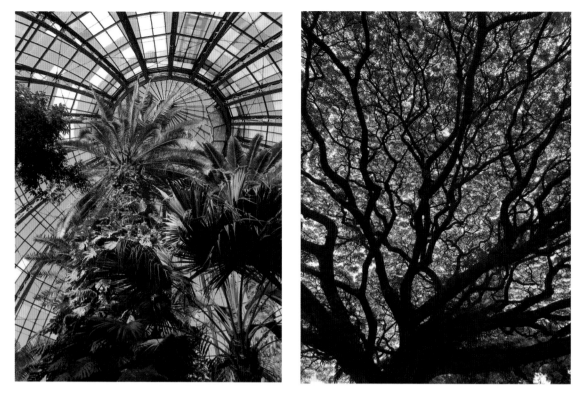

left. The image of the conservatory shows the circular roof, with the dome bending outward and the trees nearly reaching the top. Shot from a low angle, this architectural design looks similar to the sun and rays of light radiating outward. It's a clear example of radial balance.

right. The tree draws initial focus from the lower third of the image to the top. It's an image that could work vertically, as taken, or horizontally. With the wide depth of field, no detail is too small. There is an interconnectedness stemming from the base of the image to the top, reminding one of a system of veins. It's another example of radial balance.

aesthetically pleasing and have greater equilibrium.

Symmetrical balance is achieved when two or more elements of the same weight or size are balanced from the center. A good example is a wedding photograph in which the officiant is in the center and the couple are on either side.

Asymmetrical balance shows a visual balance despite the elements having a different weight, look, or size. An example of this could be a parent pictured with a small child.

Radial balance uses the focal point as the anchor of the image, with visual elements radiating out from the point of focus, similar to a watch dial or sun rays.

In mosaic balance (sometimes called crystallographic balance), there isn't a single focal point; rather, there is equal emphasis on all of the visual elements. Despite a lack of visual harmony, the balance works effectively. An example of this could be a photo of a migrating herd.

Decide which type of visual balance best fits whatever you are shooting, and compose your image with it in mind.

"In mosaic balance, there isn't a single focal point . . ."

left. These Hawaiian petroglyphs tell a story we no longer have the language to read. To the modern eye, it's intriguing, yet confusing. The carved figures are not along a straight line; they are disorderly.

right. Mosaic balance is frequently employed in art, often in images of crowds like this one, moving about their day with no uniform rhythm. It was commonly used in the modern art movement by painters like Miro and Kandinsky. It was also effectively used by ancient artists in petroglyphs, pictographs, and cave paintings.

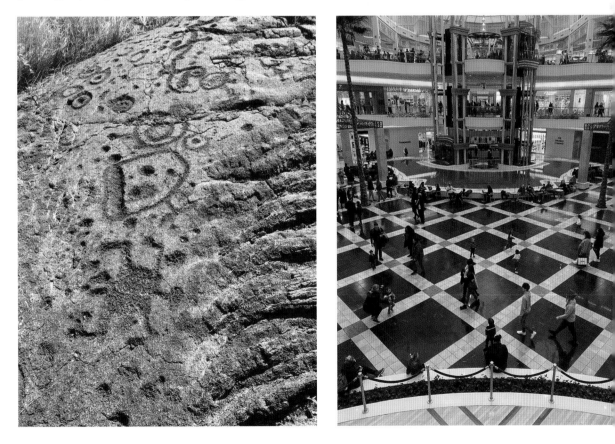

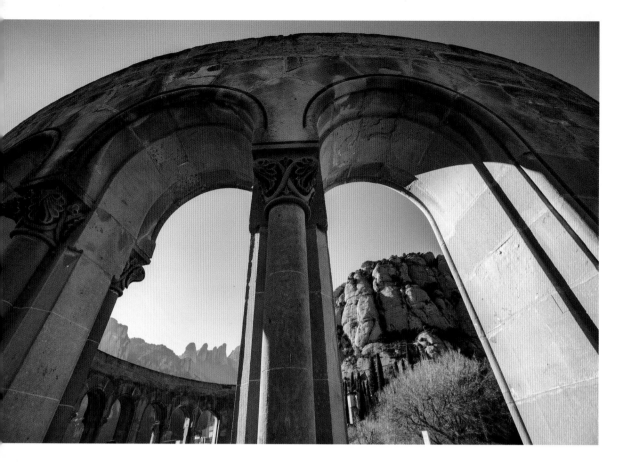

above and following page. **Vary perspectives and angles while you shoot to create the best-possible composition.**

Angles

There is no one correct way to take a photograph. Take time to vary your angle and vantage point to change the composition of each photograph you capture of a particular scene. Often, taking an image from an unexpected vantage point will result in a more compelling image than shooting from an obvious vantage point.

Shooting from lower or higher than eye level produces unique angles and different ways to view a subject. This is why you will often see professional photographers squatting. Luckily, the light weight of an iPhone allows for photographers to shoot single handed, flip the phone upside-down, and move it into spaces the body might not reach, providing opportunities for interesting angles and dynamic compositions.

Pro tip: Use the iPhone's volume up button to capture shots from odd angles more agilely.

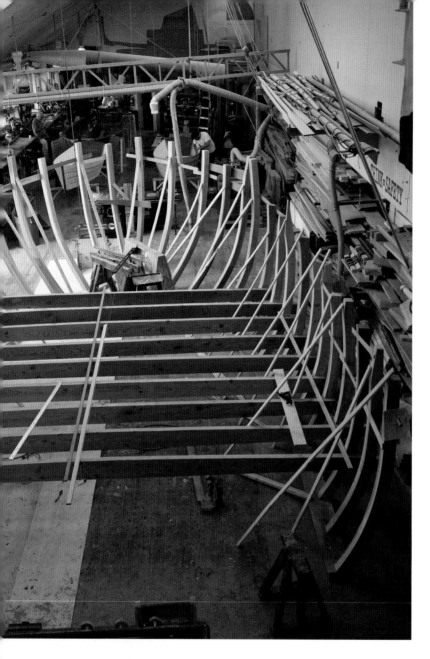

top. The image of the boat-building work-shop was shot from a balcony above. The image shows a sense of scale and size while giving a bird's-eye view into the shop and the carpenters at work.

bottom. Shooting an image of sailors walking down the steps of a ship would likely lack depth of field and be rather boring if shot at eye level. When taken from above, there is a stronger sense of place, and the shot is more dynamic.

The Rule of Thirds

The Rule of Thirds is a guiding art principle that can help you create stronger, more compelling images. The Rule of Thirds divides an image into three parts along the horizontal and vertical axises. In Western culture, where we read from left to right, the eye will naturally process an image along the intersection of each line, rather than from the center of the frame and scaling out.

The iPhone has a setting which helps users visualize the Rule of Thirds. Turn on the Grid feature in the Camera Settings to practice, and keep it on to help guide future compositions.

right. **Photojournalism, unlike fine art and commercial photography, is meant to document and help tell a story. Not every image is perfect, because, as a photojournalist, you often don't have control over your shooting environment. Use the Rule of Thirds to your advantage to produce more compelling shots.**

There are nine sections within a Rule of Thirds grid. The principal is not called the Rule of Nines because the image is meant to be divided into thirds with either horizontal or vertical sections for framing. A grid works better than lines, as it gives the photographer the opportunity to see both sets of lines and make a definitive decision along each axis.

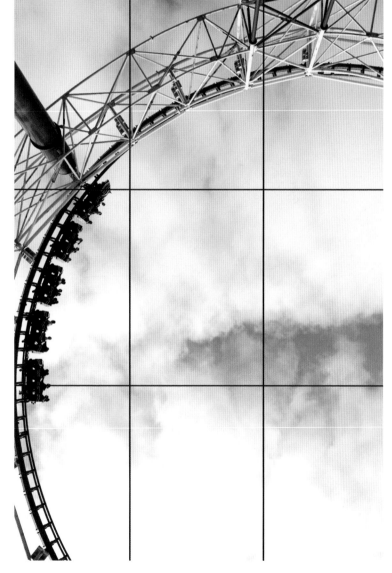

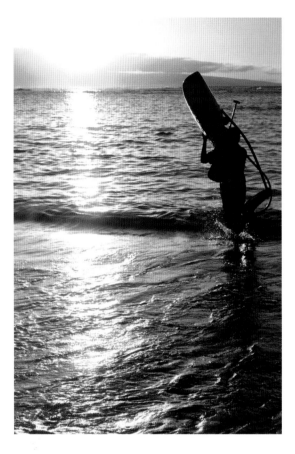

top and bottom left. Using the Rule of Thirds, experiment with positioning your main subject in the frame using the horizontal and vertical thirds lines and power points (the places where the lines intersect). This may not come naturally at first, but with practice, you will strengthen your compositions.

Fibonacci Rule

This art principal goes by many different names, including Golden Mean, Golden Ratio, Golden Spiral, Divine Proportion, Fibonacci Sequence, and the Rule of Phi. First introduced by Leonardo Fibonacci around 1202 A.D., this is one of the most widely known mathematic sequences. When applied in photography, it can be a strong tool for improving visual balance in compositions.

When composing an image using the Fibonacci Rule, envision the break of the quadrants and the spiral shape leading the viewer to the focal point.

The Rule of Thirds is a more simplified concept than the Fibonnaci Sequence, but both follow a grid. When

"The Rule of Thirds is a more simplified concept than the Fibonnaci Sequence, but both follow a grid."

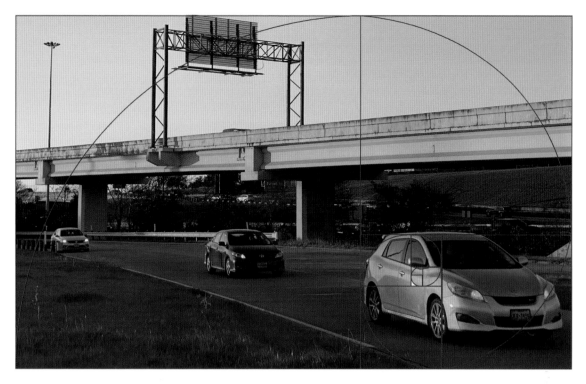

above and right. When composing a photo using the Fibonacci Rule, envision the break of the quadrants and the spiral shape leading the viewer to the focal point.

you start to apply this sequence to your iPhone photography, you will begin to see it occurring naturally in your environment and in your shots.

Leading Lines

Leading lines are lines that direct the eye in one direction. When used with intention, they can help to draw the viewer's eye to the subject. Leading lines are most prevalent in architectural elements, where straight lines are more common than they are in nature.

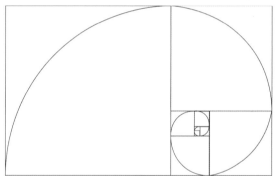

To use leading lines in your composition, be intentional about the angle you shoot from and the horizon line. Also, be conscious of your focus. Both wide and narrow apertures can work effectively.

Being aware of leading lines can result in more intriguing images that hold the viewer's attention longer.

See the images and caption on the following page.

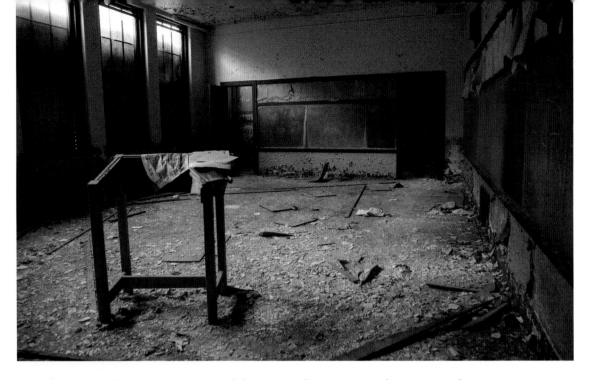

this page. An empty classroom in a condemned school appears almost ghost-like with the teacher's podium poised perfectly at the front of the classroom. I shot the image from the door of the classroom, careful not to move anything, and utilized the natural lighting. While the podium in the foreground immediately catches the eye, the leading lines of the chalk board on the right and the windows on the left guide the viewer to the center wall. The center chalkboard is framed on four corners by leading lines, and the light, coming in at an angle, leads the eye diagonally from top to bottom. Looking at the image longer, you begin to notice the baseboards are also leading lines, directing the viewer to the center. Even the board debris on the floor appears to point to the chalkboards.

Photographing this room at a different angle may not have resulted in definitive leading lines. Moving into the center of the room with the podium at the exact center of the frame would shift the focus completely to the podium.

Look closely at the image without the red lines. After studying the example with the lines drawn out, can you notice a difference in the way you view the image? Were you aware of the leading lines in the image before they were drawn out?

Architecture

Don't underestimate the visual appeal of symmetry. When shooting architecture, be intentional about the direction from which you will shoot. If you are photographing a building higher than six floors at close range, chances are, you'll need to tilt your camera upward to capture the whole structure, especially if the subject is a skyscraper. In doing so, however, the vertical angles of the building will begin to warp inward. This effect can be mitigated by

this page. **Slight editing adjustments can be applied to straighten lines if desired. Apps like SKRWT, shown here, can help to reduce lens distortion and unintended warping. This adjustment can also be done in Adobe Photoshop using skew mode; it works better on the desktop version than in the mobile app.**

shooting at a distance or from an elevated floor, but often that isn't possible.

Be aware that tilting your camera up or down will affect how leading lines appear in the image.

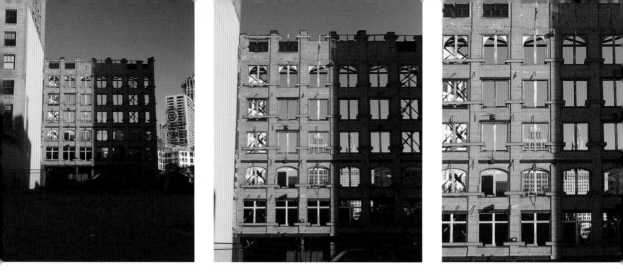

above. **Notice the difference in quality between these three images. The first image is the original. For the second shot, I used a slight in-app zoom. For the third photo, I used an extreme in-app zoom. Had I simply walked closer to the facade, the image would've been much sharper.**

Pro tip: As a rule of thumb, always make sure your horizon line is straight. That line should not appear slanted, unless it is reflected on another surface.

Zoom

The zoom feature in the Camera app should be avoided whenever possible. The iPhone uses a digital zoom, which doesn't have the capacity to actually zoom in the traditional sense. Instead, it increases the size of part of the image and crops, eliminating pixels, and the resulting image can be pixelated and blurry. The telephoto lens is a 2x optical zoom, but using this lens to zoom in further than its 2x will also result in lower-quality, blurry images.

Decisive Moment

Henri Cartier-Bresson, famed photo-journalist and Magnum Photos co-founder said, "Your eye must see a composition or an expression that life itself offers you, and you must know with intuition when to click the camera."

In photojournalism, the goal is to capture the essence of an event at the pivotal, or decisive, moment. Great photography requires anticipation and impeccable timing. Fortunately, in the age of smartphone photography, a pho-tographer can shoot in Burst mode, or quickly shoot multiple shots, to get the exact framing, not being limited by the space left on a roll of film.

this page. This garage caught my eye, but after taking the image of the wall, it was clear there was something lacking. I waited for someone to walk by, and hoped to capture them in the center of the frame to add visual interest, movement, shadow, and to show how cold the day was. I waited for the subject to walk into the center of the frame, and snapped the picture.

Seeing the results here demonstrates that waiting in the cold for the decisive moment made a difference in producing the best composition. A decisive moment image often takes time. It's a shot the photographer must anticipate, and then wait for everything to align perfectly for that intended shot.

Notice that the additional shots taken after the decisive moment aren't as interesting. When you can't control the subject or movement, it's often worth taking additional shots leading up to and beyond the desired moment to increase the likelihood that you will get the ideal shot. Sometimes you'll surprise yourself. The strongest image may be a shot taken before or after waiting for the figure to pass through the desired point in the frame.

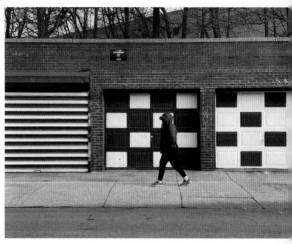

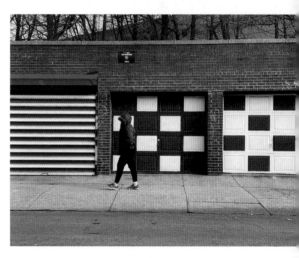

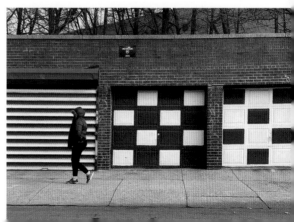

2. Lighting

There are a number of different sources of light that can be utilized by a photographer to create an interesting image.

A direct light source is the primary light source; without it, the subject would be in darkness. An example of direct light is the sun or a studio light.

An indirect light source is a secondary light coming from the side, typically bouncing or reflecting off of a surface. Examples of indirect light sources include a reflector, white wall, or sand. Incidental, smaller lights, like an exit sign, are indirect sources, too.

Backlighting exists when the light source is directly behind the subject. When accompanying a direct light source, it can help to separate a subject from other elements in the background, but on its own it creates a darkened figure and a loss in detail of the subject. Backlighting can result in a complete silhouette. Unless this is the desired result, it should be used minimally.

previous page. Understanding light is key to using it to create striking images.

right. Dappled light creates patterns of highlights and shadows on this group of children.

Dappled light occurs when a direct light source is broken up by an object, creating patterns of highlights and shadows. An example of dappled light is the light under a leafy tree, or the striped light coming through a blind. Dappled light can be used effectively, but beware of the distraction random shadows can create in an image.

Strobe light is an external professional light source that syncs to the shutter to fire a bright light at an intended time, often when the shutter is released.

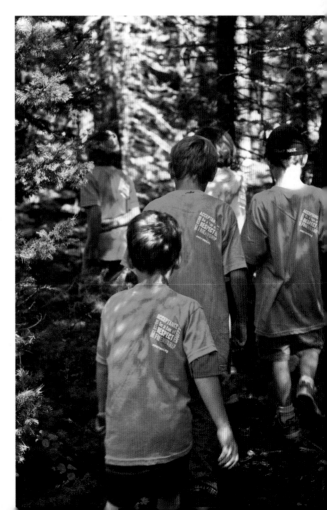

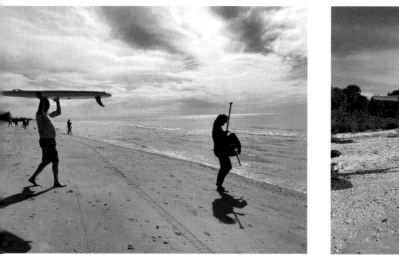

left and right. **This image of the couple walking to the shore was shot around 11:00 AM. The woman is backlit and nearly black, whereas the man is being shielded by the paddle board and is much less overexposed. In the second shot, made earlier in the day, the subjects are farther from the light source, so the sun isn't bouncing off the sand and overexposing the image. Also, the sun isn't behind them. Note the difference.**

Natural Light

Cameras need light. Natural lighting is the easiest to master since it doesn't require a setup. When shooting in natural lighting outdoors, time of day and the position of the sun are important.

Avoid taking photos of people and objects in front of the sun, unless a backlit effect is intended. Also, if the sun hits the lens at an angle, lens flare could appear in the photo.

The best time to shoot outdoors on a sunny day is before 11:00 AM or after 3:00 PM, when the sun is less severe. This isn't always possible. Look for shade, and try not to place the subject in direct light. Pay attention to the direction of the shadows, how long they are, and whether they add visual interest in the photograph.

Pro tip: Indirect light can be more flattering when shooting with natural light. Learning to use the histogram in apps like Moment Camera Pro will help you understand when the light is balanced in a composition.

Hard & Soft Light

Hard light is an intense light that casts severe shadows and produces sharp contrast. Hard light is typically considered unflattering for portraits because the shadows accentuate wrinkles, acne, and other blemishes. An example of

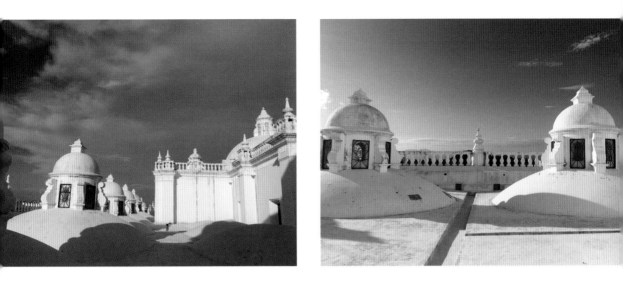

left and right. **Here is an example of hard and soft light on a rooftop. In the first photo, hard light pierces through the clouds, creating hard, rather pronounced shadows. In the second photo, shot in the early morning, the soft light casts softer, less-defined shadows.**

this would be using the camera flash at close range on an iPhone.

Soft light provides a wider throw of light, low contrast, and minimal shadows. The sky on a cloudy day is a good example of this. Soft light is more forgiving for portraits, and the resulting images require less editing.

The size of the light source and the distance between the subject and the light will determine whether a light is hard or soft. A closer light will generally cast a softer light.

Artificial Lighting

The iPhone camera's sensor is made by Sony, and it is superior to those on many other camera phones on the market. A bigger sensor is more sensitive to light. Strong sensors can reduce noise in an image, producing larger pixels and improving the range for low-light shots.

Photojournalists shooting events in a venue rarely have any control over the lighting and may be restricted from using flash. Therefore, it is very important to understand how to shoot with the existing light.

As fluorescent and incandescent bulbs can create a color cast in your images, using white balance to neutralize the color can be helpful.

Do not pose a subject directly under or directly over a light source, Doing so can produce hard light and a ghoulish effect.

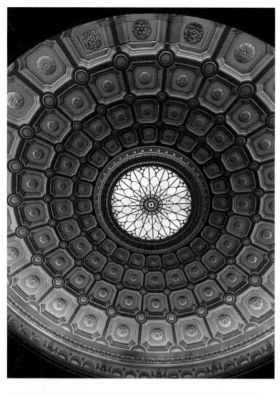

Flash, Strobes & External Lighting

The majority of commercial shoots use multiple external professional light sources. Editorial photography can include a mix of natural lighting and artificial lighting. Softboxes used for traditional camera shoots can still be used without strobe lighting for an iPhone shoot, though it is not widely practiced.

A couple of companies—like Godox, Tric, and Anker—have developed wireless flash triggers for iPhones, though they are not yet widely available on the market. Luckily, iPhone users who want to control the light have a few excellent styles of portable lights available that, like the iPhone, can fit in a pocket.

Profoto units and Lume Cubes can be placed around a room to add side light or be attached to your phone. CHSM-ONB mini LED light was invented to provide better selfie light, but can be

top. **In some instances, deliberately shooting the light source makes for a good composition, like this image of an ornate light fixture. When shooting into the light, make sure to adjust your exposure to ensure the light isn't overexposing the image.**

bottom. **You can use studio lighting to create images with your iPhone, though this is not widely practiced.**

re-purposed for shooting other subjects. These lights can give the desired effect and come in handy in darker rooms. These brands all use rechargeable batteries, making them a valuable addition to your kit, and they do not require spare batteries.

Avoid using flash underwater. Underwater flash can hit particles, which can create distracting noise in an image.

White Balance

White balance and color temperature are related concepts. Each light source is rated in degrees Kelvin. Sources with a higher temperature rating—like daylight, which measures roughly 5500°K,

impart a blue color cast in your images, while candlelight measures about 1500°K and creates a warm, golden hue in your images. Fluorescent and tungsten bulbs have different color temperatures and produce a different color cast. The human eye is good at neutralizing color casts, but cameras capture them and make them evident in images.

To remove the color cast and create neutral, natural colors and true whites in your images, you can adjust the white balance.

Automatic white balance settings like Cloudy or Shade will adjust the colors in the scene, but the results are not always precise. Manual white balance

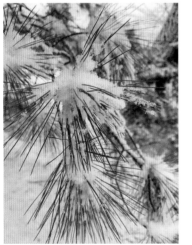
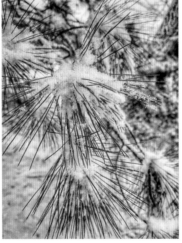

left and center. **In the left image of a white pine, the winter light gives the snow a cool blue hue. The white balance in the center image was adjusted so the whites and greens no longer have a blue color cast.**

right. **The Camera+ 2 white balance menu.**

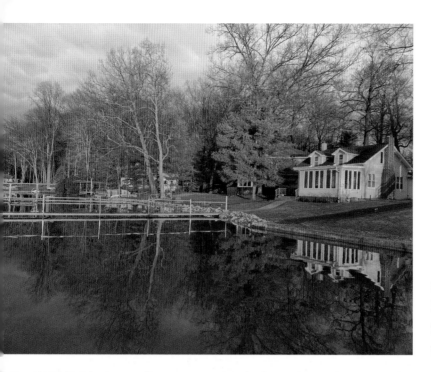

this page. Golden hour is known as the ideal time to create images with a warm glow.

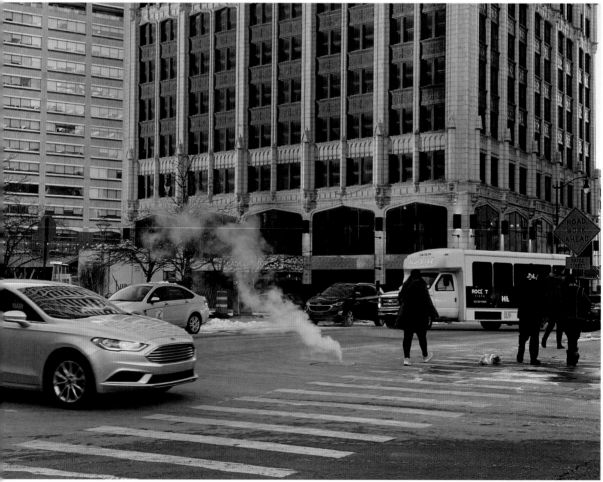

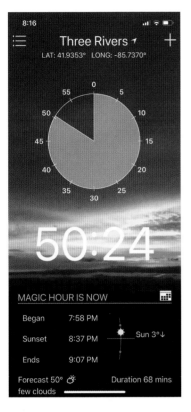

above. **The Magic Hour app will help you plan for golden hour.**

right. **Golden hour light is flattering for portraits, too.**

settings are available in many iPhone apps, including Camera+2 and VSCO Cam. They can really help you capture the image you're after.

Golden Hour

The best time of day to shoot outdoors using all natural lighting is golden hour. Golden hour is the first hour after sunrise and the hour before sunset, when the light from the sun casts a romantic, golden hue. Photographers are often "chasing light," attempting to catch the perfect golden hour image. To take full advantage, aim the camera at a surface that this warm light touches.

Golden hour does not last long, unless you are shooting in the summer

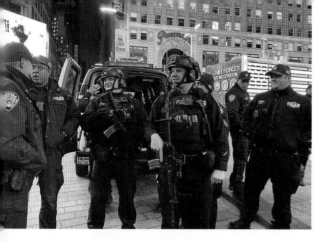

in higher latitudes, where the days are long and golden hour stretches on. Plan accordingly, or be ready when you happen across the perfect golden hour shot.

Golden light can be ideal for shooting flattering portraits. However, because the time to take advantage of the warm hue is brief, you have a short window with your subject.

The app Magic Hour geotracks your location and can identify the exact time of golden hour. It has an alarm feature you can set ahead of time to be prepared when golden hour hits.

Night Mode

Night mode, a smart setting unique to the iPhone, detects low light using the camera's sensor and self-adjusts to drastically improve the quality of the image. It will automatically turn on in darker environments. You can manually turn it off by clicking on the icon in the top left of the screen if you'd prefer to shoot without it.

When active, the icon will indicate in seconds how long the exposure will take while you're focusing on a subject. The longer the exposure, the brighter

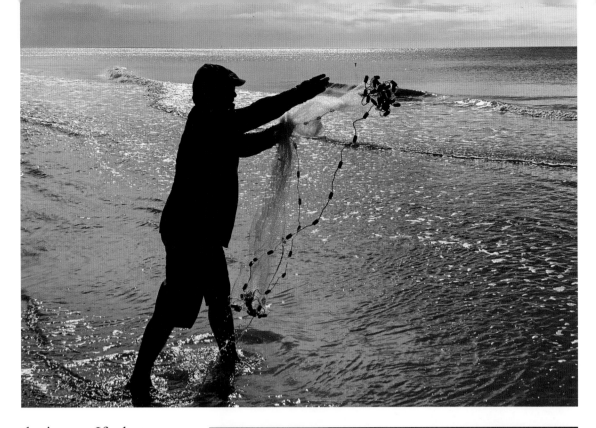

the image. If a longer exposure is necessary, adjust the slider located above the shutter. The slider will act as a timer to count down the length of the exposure. For longer exposures in low light, use a tripod to stabilize the camera.

Flash and Live Photos will not work with Night mode.

Silhouettes

Shooting with the sun or another light source behind you reduces

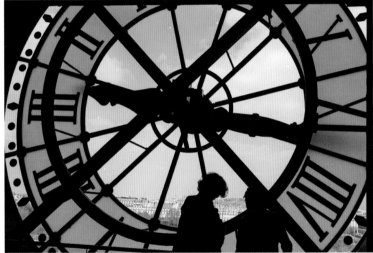

this page and following page. In some images, shadows are the main focus of the image. The silhouetted candids here show backlit men whose detail is lost. The viewer automatically fills in the blanks of the silhouette.

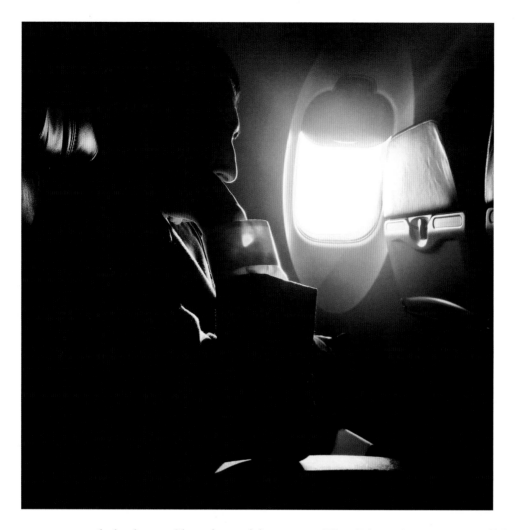

contrast and shadows. Shooting with the light source off to the side can create more contrast and longer shadows. Look for light bounce, which can diffuse the light.

Exposure has a strong effect on shadows. By increasing or decreasing the exposure, you can control the brightness or darkness of the shadow areas. However, take care not to underexpose or overexpose an image, which can throw off the tonal balance of a picture.

The iPhone's exposure slider makes it easy to view the exposure changes prior to taking the image. Apps like Pro Camera have a live histogram that overlays on top of an image, indicating if it is overexposed or unevenly lit.

Mastering shadows will build visual intrigue and strengthen your compositions. If the shadows are too severe and you want to pull in more detail, adjust the exposure. You can also use a fill flash or an external light.

3. Weather

Photographers should be comfortable shooting in all weather conditions. Weather can change abruptly, so it's good to be prepared. Fortunately, recent versions of the iPhone are less sensitive to water, which makes shooting in rain, sleet, or snow less risky to the phone.

When shooting in heavy rain, snow, or hail without cover, place your less dominant hand on the top front of your phone to shield it. In wetter environments, it might be worth investing in a waterproof case. Ziploc bags can make excellent cheap waterproofing in a pinch, and they are easy to carry, but be careful, they can tear, and often leak.

Pro tip: When shooting in precipitation or heavy winds, be sure to lock focus before taking an image. The movement makes auto focus produce inaccurate results.

An external microphone with a windsock will reduce noise while shooting video. In windy weather, a Gorilla pod or tripod will reduce shaking caused by wind, but be sure to secure the phone and the support before letting go.

When shooting in snow or sand, manually adjust the aperture to ensure your subject isn't overexposed, as the

above. **Use a Ziploc bag to weatherproof your iPhone when shooting in rain or snow.**

camera's sensor and settings will be affected by the bright reflected light.

Counter to many people's expectations, bright, sunny skies do not make for ideal shooting weather. Direct sun can create harsh, unflattering shadows. If the weather is very hot, there may be

fewer people outside. If shooting portraits outdoors in the hot sun, your subjects may be sweating, makeup might be melting, and they will likely squint, which is generally unflattering.

On sunny days, a fast shutter speed and ISO of 100–400 should produce the best images. Adjust accordingly if photographing action or panning.

When possible, get your subjects out of direct sunlight by bringing them indoors and putting them by a window, bringing them into the shade when the sun is bouncing off nearby surfaces, or using a reflector to block harsh light.

Many photographers favor cloudy weather. Cloudy skies diffuse the sun, casting a more even light with fewer shadows, which is more flattering and easier on your portrait subjects. Clouds can also add more visual intrigue to an image.

below. **Overcast skies can make for more even exposure.**

top and bottom left. A clouded sky acts as a softbox, diffusing light rays. This makes for soft, flattering light for a variety of subjects.

right. The Eiffel Tower was shot from a low angle in a composition that is atypical of most images of the monument. When shooting well-known landmarks, try to find a new way to portray them, to give the viewer new details to look at. The sky was overcast and gray that day, and while I might have envisioned an idyllic scene with a bright blue sky, cloudy weather is more typical of Paris.

Pro tip: To show the impact of weather, look for trees that might be damaged, people stuck in rain, or houses buried in snow. These human elements help to tell the story of the impact of weather.

4. Reflections

Reflections can provide visual intrigue and add interest in subjects considered to be dry by many photojournalists. However, shooting reflections presents its own set of challenges. For best results, use a smaller aperture, around an f/10. For smaller objects, an f-stop of about f/5.6 will produce more consistent results.

Avoid shooting at midday if sunny, and opt for low light, when the chance of glare is minimized. Focus on the reflective surface when using a wide aperture.

Shooting with an iPhone allows you to get closer to your subjects than a DSLR, but be mindful of the composition. If you get too close, you may warp the subject, and your phone will appear in the reflection.

> ## *"Avoid shooting at midday if sunny, and opt for low light, when the chance of glare is minimized."*

previous page, this page. Reflections can make for an evocative image. Avoid shooting at midday for the best results.

5. Color

Color can be as important as focus in a photograph, because the eye is naturally drawn to bright, bold colors. Color can set the mood in an image and draw focus to an essential part of the composition, too. Colorful images are striking and hard to ignore, which is why they are popular among advertisers, who favor bold, rich colors over subdued palettes. They are also popular with photojournalists.

Color photographs can be used to best illustrate the time of year. In climates that have distinctive seasons, the colors in nature are different in fall than they are in summer. Think of the color palette people tend to wear in spring, and how different it is from the colors people favor in winter. A black & white image of an infant tells you less than a color image of a baby, since a very young child is often wearing pastel pinks, purples, and yellows, or blues, browns, and grays—colors that signify gender.

Color can be an important aspect of visual storytelling. Being conscious of the role color plays in images can inform the composition. In the digital era, colorful images with high saturation have become a popular editing style. If a photo features muted colors, adjusting the saturation, contrast, and white balance in your preferred app will enhance the image. Just don't overdo it, especially when shooting photojournalism, which is meant to look natural.

Color can also be used to highlight an object in an image with very little color or color variation.

left. **Though the majority of this image is white and brown, the streak of turquoise going up the staircase immediately draws the eye.**

following page. **Colorful photos attract the eye, and color can help to tell a story in your images.**

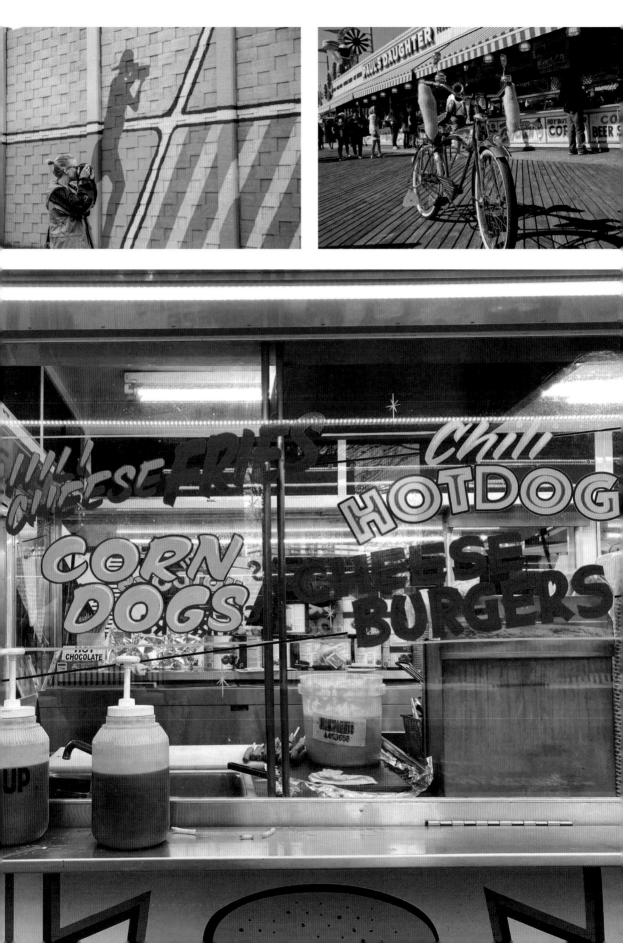

6. Black & White

The first journalistic photographs were black & white, as are many of today's newspaper images. Some photographers choose to shoot primarily black & white as a creative choice. For black & white iPhone photography, there are two main options: shooting in black & white, or converting from color to black and white in postproduction.

To shoot in black & white using the Camera app, press the top center arrow, then select the Filters icon. Apple offers

below. **The three filters available on the Camera app produce different black & white tones. From left to right: Mono, Silvertone, and Noir.**

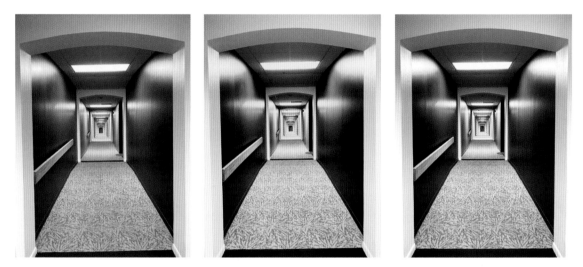

below. **Shooting with black & white specific photo apps will result in different effects. Here (from left to right), I used Carbon, Black and White Picture Camera, and Black-White Photo. Compare these images with the photographs taken with the Camera app.**

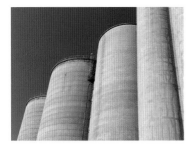

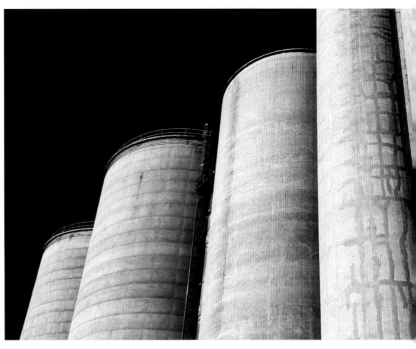

this page. **Here is an example of an image of a mill, shot in color and edited in black & white, using the Simply B&W app, which allows a lot of control over settings and a handful of filters. Shooting in color provided a greater number of options. After editing it as black & white, it's clear that removing the color makes a bolder image.**

three different black & white filters: Mono, Silvertone, and Noir.

The Mono filter produces the look of monochromatic film. The Noir filter is high contrast and was inspired by Film Noir's signature dark-black and bright-white aesthetic. The Silvertone filter attempts the look of silver gelatin prints—a popular traditional black & white film printing process that uses actual silver as part of the chemistry in developing the print, resulting in a crisp black & white photo with a silver sheen. Unfortunately, this look is hard to replicate digitally, making Silvertone less successful than the other two black & white Camera app filters in producing a comparable image.

The Camera app renders the images in grayscale, so the shot is visible in black & white on-screen before you press the shutter button. Images shot

using a black & white filter on the Camera app are non-destructive. This means the camera actually takes a color image, then applies a filter overlay that removes the color. If you decide after taking the photo that you prefer it in color, you can scroll through the other filter options to change from black & white back to color. This is not the case with other apps that shoot in black & white.

Shooting in color and then editing the image allows you to decide whether the shot is stronger in color or black & white and allows for the use of a range of filters available in various apps. These apps offer a broader range of fil-

ters and editing options than the Camera app, and they are usually straightforward and easy to use. Each app has slightly different features, so it's best to experiment to see which is right for your needs.

When shooting in color, an image is often framed to optimize color and balance, while in black & white photography, those elements are stripped away so there is greater focus on light, contrast, and the subject. Shooting in black & white helps to train your eye to look for subjects that make strong black & white photos. If shooting in color is your default, try shooting in black & white to see whether you notice a

difference in your approach to framing images.

In a black & white image, the fundamentals matter a little more, because without color, there is less to draw the eye. Shooting in black & white is less forgiving and requires more practice to perfect your technique.

A strong black & white image has tones that range from true white to deep black. This isn't always the result you initially get from the filters and apps. Experiment with exposure and contrast to obtain your desired result. Some photographers prefer an image with various shades of gray, and some favor high-contrast black & white images. Create alternate black & white edits for the same photograph—some low contrast and some more dramatic—and then

determine which approach you find more appealing.

Pro tip: Even black & white images need to have tonal balance. Aim to have a range of tones from a true white to a dark black in each photograph.

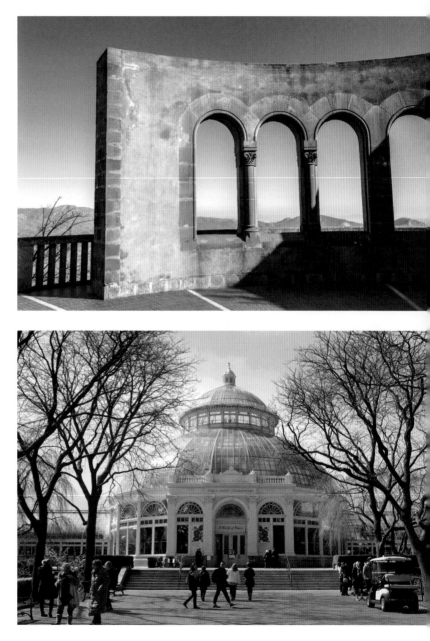

previous page and this page. Shooting black & white images is not very forgiving. You'll need practice to perfect your technique.

7. Macro

Macro photography is not commonly used in photojournalism, but in some instances, it can be quite effective. The iPhone camera's telephoto lens allows for good macro shots, but for extreme close-up macro shots, external lenses are required. External macro lenses are among the most popular lens sizes currently being produced.

To get the best focus using your iPhone, with or without an added lens, get close so that you are almost touching your subject. Some lenses work even better when *touching* the subject.

Pro tip: Consider creating depth in macro photography. Keep the foreground in focus, but use an aperture that blurs the background.

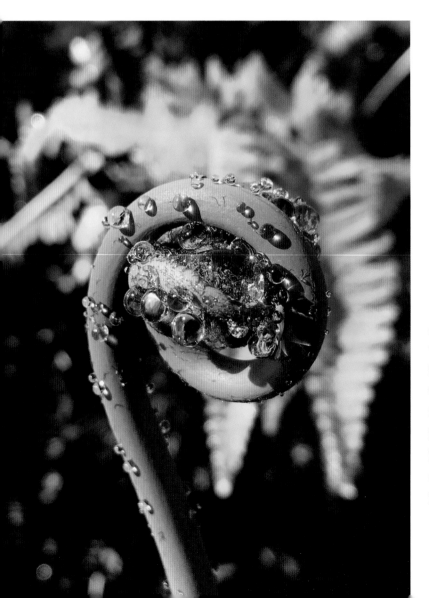

left. **This shot of a fiddlehead fern was taken at close range with an iPhone 6 using the Camera app, proving that even older iPhones can produce compelling macro images.**

8. Audio Recording

Recording audio during an interview is a journalistic practice almost as old as audio recording itself. Field recorders have evolved from bulky devices to apps on your iPhone. Every reporter has their favorite app, but most now use their smartphones almost exclusively in place of traditional sound recorders when working in the field.

The iPhone Voice Memos app records sound and saves it by the location name. It will also automatically save to the iCloud account the phone is signed in to. In Voice Memos, you can edit the

left and center. **Here are screenshots of a sound recording of Martin Luther King Jr.'s "I have a Dream" speech, transcribed in Otter Voice Notes. The first image shows the functionality of the app in use, and the second shows the saved file, complete with saved automated keywords.**

right. **The screenshot of Apple's Voice Memos' trim editing functionality, a fairly intuitive feature.**

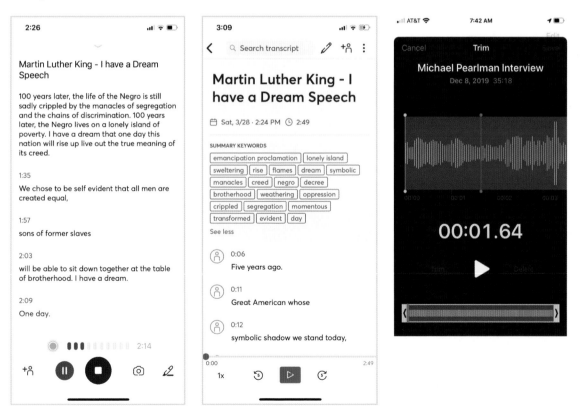

clip by trimming the memo or recording over sections of the clip. To trim the Voice Memo select the ellipses (…), then click Edit. Next, select the icon that looks like a square with dots on the left and right corners. By swiping right or left along the yellow arrow, you can shorten the clip's starting or ending times.

Apps that serve as traditional audio recorders include Voice Record Pro, Voice Recorder, and Audio Editor. Other apps, like Evernote, record audio and allow you to take notes in the app. Otter Voice Notes transcribes the recorded audio and assigns identities to speakers' voices, making it much easier to record multiple speakers. Rev Voice Recorder offers human transcribers who review your audio and transcribe without the errors of AI, though this is a pay-per-minute feature, and the cost can add up.

There are a number of apps on the market. Look for one that suits your needs and is easy to use. When recording audio, remember to keep the iPhone close to the interviewee, and keep the phone on a flat surface to avoid wobble and unintended noise.

Pro tip: For a clearer range of sound, use an external microphone attachment.

These tools are effective for journalists, but will require a spelling and grammar check.

> ## *"For a clearer range of sound, use an external microphone attachment."*

left. Face masks can muffle sound. For better quality, keep the phone close.

following page. Always save your original image files. Most news outlets now require RAW files or uncropped shots. Also, the originals serve as proof that the image accurately represents the subject or scene.

9. File Saving

Link your iCloud account to your iPhone. This will send all of your images to the Cloud. If you need more space in your iCloud, you can upgrade your account, or simply weed out any photographs you no longer need. You can easily bulk download images from the iCloud, too.

It's good practice to save your best images in multiple places, like an external hard drive or another Cloud account. This way, if your account gets deactivated, your iCloud is full, you lose your phone, or you need to access your images when you don't have Internet access, you have another option.

Additionally, other third-party apps can help you edit and save your images. One example is the Adobe Lightroom app, which allows you to edit on the go and save to your Adobe Cloud account.

Always keep your original files. Should you be asked to produce an original as evidence, you will have it.

Many news outlets now require unedited RAW images or uncropped images for major stories. These are primarily used as proof that the photographer isn't attempting to hide, mislead, or alter a scene, and these unedited files serve as a form of insurance for the news outlet.

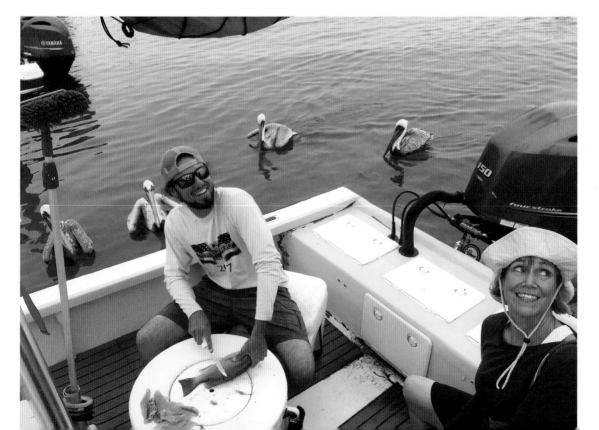

10. Rules of Thumb

Diversify

In the modern journalism landscape, having a skill-set that goes beyond your primary field can be a huge asset. Don't underestimate the power of being a multimedia journalist.

Hone your writing skills and write about the topic, or provide lengthy

below. **Taking great images is only one of the skills you need to make the most of your career in photojournalism.**

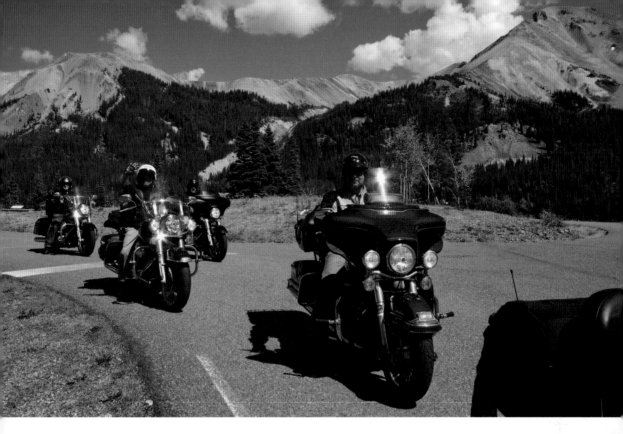

above. **In some instances, like this one, video would be as effective as a photo.**

captions. Record video and sound along with your photographs. Consider the many ways to tell the story. Which of those ways would be the most effective? Which platform does this story fit best within? Experiment and take risks.

If you can hone your video skills and your diction in recorded interviews, you might have success in other media formats, such as podcasts or television news.

Break the Rules

Your phone is the best tool to help you with almost every digital medium.

Understanding the fundamentals of photography will improve your iPhone photos, but not every rule needs to be followed to a T.

The rules exist as guides to equip photographers with the knowledge of the principles that make a strong image. Not all of these rules are unique to photography. Some, like the Rule of Thirds, apply to all visual art.

Once you've mastered the fundamentals, experiment with the framing and composition.

11. Video

Getting Started

When shooting video, manually set and lock the focus on your iPhone; otherwise, it will often attempt to refocus during filming. To lock the focus, tap on the object that needs to be in focus. A yellow highlighted AE/AF lock box will appear. Select it to lock focus.

To begin shooting video, use the horizontal orientation, unless shooting specifically for social media. Apps like TikTok and Instagram's IGTV work best with vertical videos.

Put your phone on airplane mode. There is nothing more unprofessional than having a call interrupt your shoot. Clean your lens thoroughly. Plug in your iPhone if you will be shooting for long periods. Use a battery pack if shooting outdoors.

Getting quality video for a live broadcast or for online content requires using a tripod or another stabilizer to avoid camera shake. For on-the-go video, a gimbal is an easy-to-use tool to reduce shake. Made most popular by the vlogger and prosumer communities,

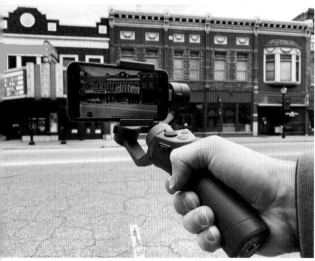

top and bottom. **Use a gimbal—a 3-axis stabilizer—for your video work.**

gimbals have taken off in only a few years, in part because they are compact and affordable.

Frame Rate

There are video apps on the market that are more dynamic than Apple's Camera app. Experiment with the functionality, look, and feel of each app, and the video quality they produce, to find one that suits your needs. Adobe Premiere Rush, Filmic Pro, Moment Pro, and Pro Cam 3 are amongst the most popular with professionals.

Pro tip: Remember to shoot in 16:9 unless your editor requests a different ratio.

below. Use a tripod for stability.

When shooting video, be mindful of the frames per second (FPS). 24 FPS has been the standard for film for many years, though some filmmakers have begun to experiment with faster frame rates. The default setting for shooting video on an iPhone is 1080p HD with 30 FPS, which remains a popular frame rate for television. You can change the FPS in the upper right-hand corner of the Camera app. You can also change from shooting in HD to 4K.

Be aware that the file size of videos; 4K videos will be especially large. Before filming, it's a good idea to ensure that there is ample space on your iPhone and iCloud, and that your iPhone is fully charged or plugged in.

B-Roll

When shooting video, be sure to shoot B-roll for padding and establishing shots. B-roll is additional footage that supports or adds atmosphere to your main shots. For example, if you are conducting an interview with a chef, B-roll could be an establishing exterior shot of the restaurant and close-ups of food preparation or other details of the restaurant.

For the best-quality indoor shots, supplemental pro-grade video lighting will produce the most evenly lit subjects. While the built-in flash can

be useful in a pinch, it is generally not recommended for shooting video.

An external microphone is also advisable for optimal audio quality. Many microphones can now be plugged directly into your iPhone. Others still require the use of an adaptor.

You may need still images from your video for thumbnails or for promotional use. Luckily, there are apps like Vphoto and Frame Grabber that make selecting a still from a video file easy, allow for editing of the image within the app, and integrate with social media platforms, making sharing images a simple task.

Editing Video

There are many video-editing apps on the market, including Adobe Premiere Rush, Movie Pro, and VN Video Editor Maker VlogNow. These apps share similar features. For short content such as reels or social videos, editing video on your iPhone is sufficient. For footage longer than 5 minutes, editing on a computer is faster, offers a greater number of features, and is easier to manage.

Use professional over-the-ear headphones to determine the quality of the sound. An external monitor is most helpful to view your footage and has a wider editing area than a small laptop

top and bottom. **Two still images of coastal San Diego, taken from video.**

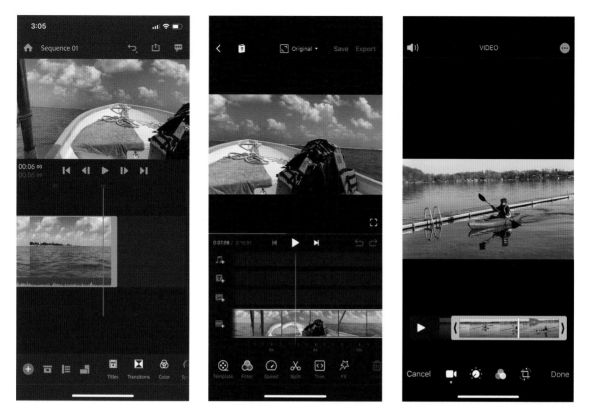

above. **Adobe Premier Rush interface (left) VN Editor Pro interface (center), and Apple Camera app (right).**

screen. Adobe Premiere Pro is the current industry standard for video editing, though other software on the market, such as Final Cut Pro, is also widely used.

Time-Lapse

Time-Lapse mode can be a great way to capture a long scene with a short video. Swipe left to select the Time-Lapse mode in the Camera app. Be sure to select and lock your point of focus and exposure before starting the video.

It is nearly impossible to maintain focus in a long hand-held, time-lapse video without a tripod or other stabilizer. If time-lapse videos are something you film often, you may be better served to shoot using apps like Hyperlapse and OSnap, which offer a wider variety of settings, like controlling the speed of the time-lapse.

Once a time-lapse video is taken, basic edits like color correction, exposure, cropping, and even shortening your clip can be done in the Apple Photos app.

Pro tip: Time-lapse videos can be easily dissected if there is a frame you'd like to use as a still image.

12. Photographing People

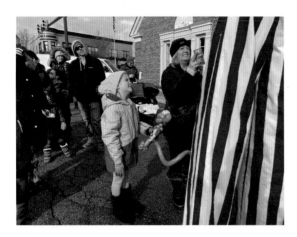

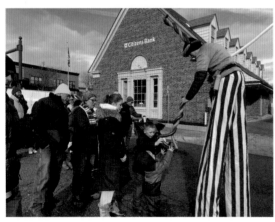

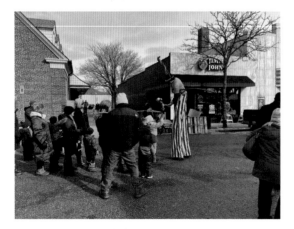

Rules & Releases

Working in photojournalism requires the ability to quickly develop a rapport with strangers of all backgrounds. Taking photos of people in unfamiliar locations can be intimidating. The best approach is to be confident, friendly, and respectful.

In the United States, photographing in public spaces is legal. However, not all property is public, so be mindful of where you are shooting, and comply with the owner's requests while on private property. Shooting from a public space into private property—for example, from the street into an apartment window—is considered a breach of one's reasonable expectation of privacy and is often illegal.

A release form is not needed for most editorial content.

top, center, and bottom. **In these images, kids and their parents gather around a clown selling balloon designs. When telling a story, experiment with point of view, and vary framing. Each of these images tells a slightly different story, though they were taken minutes apart. Be intentional and move around your subjects when possible.**

above. **A model release form is not required for most editorial work. For personal projects, get a signed release.**

Publications have different standards and requirements for model release forms. If shooting video, a verbal permission recorded on camera is often sufficient. Check with your publication before going on assignment, and ensure you have copies of these forms if required.

If shooting for personal projects, model release forms can be drafted by legal council or made from templates online or through apps. Apps like Easy Release, Model Releaser, or Image Release allow signees to draw their signature on the screen to sign, and a completed copy can easily be emailed to them.

Photographing people with iPhones is much less intimidating for both the photographer and the subject than shooting with a DSLR. Subjects are much less suspicious of an iPhone.

Portrait Mode

Portrait mode creates a narrow depth of field, blurring the background. This can be adjusted by pressing the focal length *(f)* button. The default lens used in Portrait mode is the wide-angle lens; to use the telephoto lens on the iPhone 12, tap the 2x button located in the bottom-left corner.

Portrait mode offers a range of lighting options and filters to optimize the quality of the image. In Portrait mode, the camera will also indicate if you are too close or must get closer to a subject.

Pro tip: When covering a personal story, do not shoot selfies. Selfies taken at close range create unflattering warping of the face and are generally too close-up to show anything but the face.

Pro tip: Be cautious when adjusting the aperture. When taken to extremes, the shallow depth of field can leave a blurred halo around the subject, which can look more surreal than flattering.

Environmental Portraits

Environmental portraits are the most common style of posed or semi-posed portraits published editorially. An environmental portrait illustrates the subject in their natural environment, whether it is at work or home. An environmental portrait should show elements of the person's life within the frame to help tell the story. Shooting in an area that's familiar to the subject can create great ease, especially if they aren't comfortable in front of a camera.

When shooting environmental portraits, first survey the scene for visually interesting areas, then monitor the lighting. Natural light from a window, an open garage door, or a skylight can be the easiest to work with in confined spaces, where it might be difficult to set up external lights.

Begin with a couple of formal or posed shots. Make casual conversation with your subject to get them comfortable. After you've taken the initial formal shots, let the subject lead. Be a fly on the wall as the subject engages in their profession or noteworthy hobby as they would normally. You may not need the formal shots, but it's good to have them in case your photo editor wants to go with a more classic portrait.

top and bottom. **Both of these images were made in Portrait mode.**

Experiment with the poses and scene, when possible. For example, if you are photographing a chef, take pictures of them cooking or managing a kitchen during a busy meal time. This will produce very different images than if you pose the chef leaning against a cutting board, casually holding a knife. The

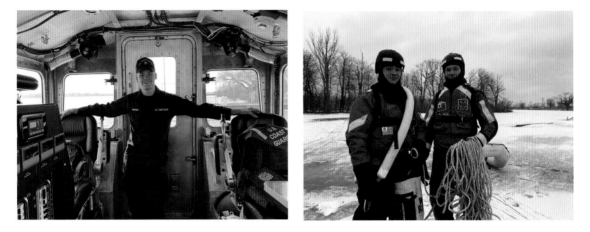

top and bottom. **Here are two very different environmental portraits of Coast Guard officers. In the first image, the young officer is casually posing on a rescue vessel. In the other image, the men are in the field having just completed an ice rescue. They are wearing weatherproof attire and holding gear. Both environmental portraits offer a glimpse into the life of the U.S. Coast Guard, but each tells a different story.**

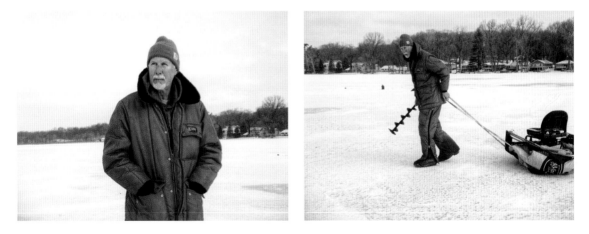

top and bottom. **The two pictures of the ice fisherman tell a more complete story together than they do separately. With environmental portraits, a close-up coupled with a wide-angle shot can show more of your subject's world and make for a stronger representation than would a single image.**

environmental portrait should be true to the subject's behavior and surroundings. Keep the subject comfortable for the strongest results.

Burst Mode

Burst mode is an iPhone setting which takes up to ten photos per second. It is best used for capturing people and things in motion.

Before using Burst mode, select and lock your focus. Press and immediately drag the shutter button to the left for portrait-orientation photos. For photographs in the horizontal format, press and immediately drag the shutter button up. Release the shutter button when you're done shooting.

After taking a set of Burst mode images, go to the Photos app, click Albums, and select Burst. Press the Select button. From there, you can view the images in the set.

After selecting the best shots, press the Done button in the top-right corner. A pop-up lightbox will appear, asking whether you wish to keep all of the images or only those selected. Use your best judgment on whether to delete or keep every shot, but be mindful that all

left and right.
Apple's Burst
mode interface.

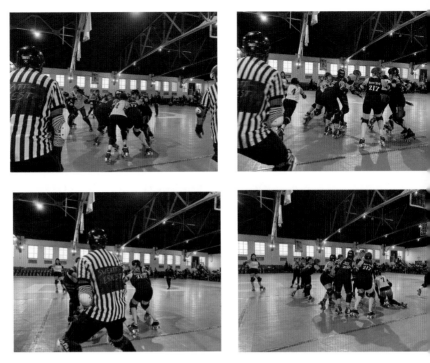

this page. **Burst mode is great for capturing motion—but it works best with few subjects with more isolated action than present in this series.**

those Burst mode photos will fill your iPhone quickly.

Utilize the iPhone's Burst mode when shooting fast action. If you choose not to use Burst mode, the best approach when shooting fast action is to anticipate the action coming into the frame and to release the shutter seconds before the action passes. The iPhone shutter may lag slightly in low light. To compensate for this, press the shutter early. Alternatively, use an app that allows for manual shutter speeds.

A common mistake when using Burst mode is hovering over the shutter before sliding your finger. If you do this, the Video mode, rather than the Burst mode, will be activated. To avoid this, be quick to slide the shutter.

If you are using Burst mode to capture the perfect frame in fast motion, remember you can always pull still frames out from video.

Live Mode

Live mode can be used as an alternative to Burst mode. Live mode takes three seconds of video and creates a live photo, or a very short video clip. A Live mode photo will begin 1.5 seconds before you press the shutter, and extend 1.5 seconds after the shutter is released. Live mode is the button in the top left that looks like concentric circles. There are three settings for Live mode: On, Live Auto, and Off.

Live mode is a good option for fast action or movement. When you are

photographing children who won't sit still, Live mode gives you more chances to get the perfect shot.

Once a Live photo is taken, you can edit it by swiping up on the image. You have a couple options to create fun effects, including Bounce, Loop, and Long Exposure. Bounce will make a video that repeats in a reverse loop so the motion is forward and backward, in the same style as Instagram's Boomerang feature. Loop creates a short repeating video similar to an animated GIF, which can be ideal for sharing on social media. Long Exposure creates a still image with elements that were in motion appearing blurred.

In Live mode, as in Burst mode, you can select the frame you want by viewing a set and clicking on the desired frame.

Sensitivity

Some groups do not permit photographs for cultural or religious reasons. Ethnic groups that do not welcome photography include some Native American, Aboriginal, and Amazonian tribes. Religious groups can include some Amish, Mennonites, Orthodox Jews,

left, center, and right. **The Live mode interface.**

above. **This image is of a group of Mennonites visiting a museum. They didn't mind the few shots I took because I didn't show their faces. I did not get too close, and captured the moment as unobtrusively as possible. This shot is interesting due to the juxtaposition of their traditional dress with the antique airplane. Both appear to be of another era, but what is most notable is the fact that the majority of Mennonites do not partake in air travel.**

Muslims, and other sects. Come armed with this knowledge before you begin photographing their communities.

Be aware that not all groups of the same religion or ethnicity may share the rigid prohibition of photography, but those who do will not take kindly to a camera. For example, some Mennonite groups allow candid photos, but not posed portraits. Some groups limit the proximity of members of opposite sexes, so be sure to maintain a respectful distance.

Live Events

Arrive early to scope out the space, survey the lighting, and identify good angles. Having press credentials to shoot an event will grant you security access to get closer to the stage or subject—and perhaps some backstage access—but it isn't always necessary.

top and bottom. For the first shot, I found the best angle by squatting down. My eye level was parallel to the center point on the sheet of ice, or about knee high. For the second image, the sculptor was on a stage, so I shot upward from a low angle.

a large group of people, so come equipped with an external lens if you can. All external lenses are currently prime lenses, which cannot zoom, so use your feet to get closer.

Pro tip: Check the weather before you head to the event you are shooting.

Crowds

Crowds tend to form around areas of excitement. Be sure to capture the anticipation or reactions on your subjects' faces in addition to documenting the action. It may be a good idea to move through the crowd to the front, then crouch down for an interesting

Move within the space, get into the crowd for reaction shots, and try different vantage points.

Using the iPhone's built-in lenses can be limiting when you are photographing

vantage point that doesn't block others' view.

When photographing crowds on an iPhone, use manual focus. The auto focus may not provide the range of focus needed.

Try a mix of wide-angle images and close-up shots of people within the crowd. Does the crowd need to be the focus, or is the rest of the scene more important in telling the story?

For most event shoots, you probably won't have access to a green room. You may be forced to park far from the venue, so don't overpack your bag. A bulky backpack can make maneuvering through crowds challenging. Bring only what you need.

left and right. **In the first image, the focus is on the couple in the lower third of the frame. The second shot has a wider focus and slightly wider crop. Either approach could work, depending on the story that must be conveyed.**

left and right. **Photographing with an iPhone rather than a DSLR allows you to better blend in with the crowd.**

When photographing dense crowds, take note of emergency exits and other routes away from the action. Rallies, protests, and other large gatherings can become dangerous quickly, and if this happens, being a member of the press can make you a target. Wearing comfortable shoes can allow you to be more agile if you need to move quickly.

Photojournalists often put themselves unnecessarily at risk. Photographing with a DSLR will draw attention. Using your iPhone to document events can help you to better blend in with crowds. Use this to your advantage.

Sports Photography

Sports photography can be a challenge to shoot on the iPhone, even in Burst mode, for two main reasons: proximity and speed. There is a reason why most photographers use DSLRs with telephoto lenses when photographing sporting events: they want to get close-ups of the action while working

top and bottom. **The iPhone is a great tool for shooting close-ups, preparations, and the more sedate moments in sports.**

above. **This is a good example of a sports image that required a wider aspect ratio. The participants are spread out, not huddled together, as they might be on a field.**

from the sidelines. Even with accessory telephoto lenses, the iPhone cannot yet compete with traditional cameras and lenses in terms of magnification.

Most sports are fast action, and the optimal shutter speed for most sports photography is around $^1/_{1000}$ second. While the iPhone can shoot at $^1/_{8000}$ second, it is best to use the Camera+2 app or a similar app that allows for manual shutter speeds. Also, you will want to be sure to set the shutter speed before the action starts.

The iPhone is not the most effective tool to document fast-moving sports, especially from a distance. However, it is a great tool for slower sports that allow photographers to shoot at a closer range, like hunting, fishing, and even skateboarding.

"The iPhone is not the most effective tool to document fast-moving sports, especially from a distance."

13. Telling the Story

Don't neglect the detail in an image. If something you are shooting has interesting features or embellishments, don't overlook them. Often, small details that might go unnoticed are the most thought provoking. Vary your shots from wide angles to close-ups.

Details matter in journalism, and shooting detail shots is essential to telling a well-developed story.

top and bottom. **The first image is a 30-foot ice cream cone located roadside along Route 66 to attract drivers' attention to the adjacent ice cream stand. These roadside novelties were ubiquitous along Route 66, and while the first image is fun and unexpected, the eye lands on the plaque that can't quite be made out. The close-up shows the plaque front and center and the cone, but not the ice cream, allowing the viewer to make the mental leap to what the statue could be. The wording of the plaque and quirkiness of the image add humor. A publisher might use both images, as one informs the other.**

left and right. Detail shots of architecture show the craftsmanship that went into the building. These shots are of an ornate elevator in Detroit's Fisher Building, one of the top-ten most ornate Art Deco buildings in the world. Showing the detail in this design illustrates the elegance of a bygone era.

below. You can show details in the foreground while capturing the scene beyond. Here, the focus is on the abdomen of a Coast Guard officer. You can clearly see his logo and rescue gear. You can also see another officer preparing a rescue vessel on the ice. The framing draws the viewer in because it takes a couple seconds to understand what is happening in the image.

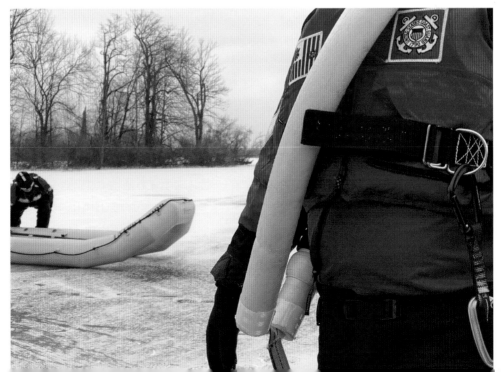

14. Ongoing Projects

Ongoing or long-term projects require a different level of commitment, development, strategy, and planning than short-term projects necessitate. Begin by establishing clear goals. You don't have to share these with anyone, at least not until you have completed a substantial amount of work, unless your editor is invested in the project. Having defined goals will help guide your work and

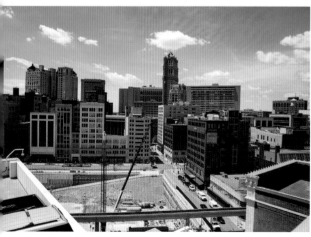

supply you with a concise pitch, which you'll need when you're ready to share the work, apply for grants, or interest editors.

Research your topic: the region, past photographic work that might be similar, etc. This will provide you with the foundation you need before you go into the field. It will allow you to ask questions, dig deeper, and avoid treading ground that has already been covered. Asking yourself questions like, "Why is this important?," "Who is affected by this?" or "Why should people care?" will inform your approach. As you get further along in the project, you'll need to ask yourself more pointed questions pertaining to the topic. If appropriate, you can share some of these questions with your subjects. If, through your research, you discover that others are

top and bottom. **Here are two images of a quickly changing Detroit. As a Detroit resident, I have seen the rapid downtown development, with numerous construction projects altering the landscape. Photographs of your surroundings, especially urban landscapes, make great evergreen stock content. This will be explored in detail on pages 109–11.**

working on the same issues, determine if it would be best to collaborate with them.

Consider your audience. Define who your audience is for the project and how your work will appeal to that demographic. As a photojournalist, it is your responsibility to ensure that this work gets seen, and if your subject is human, they will expect it. So, during the project, don't lose sight of how you will present this work to the public.

Equally important is your approach to documenting the story. Continuing to think about technical details, including which ratio to use, what lens to shoot with, and whether to add video or audio will impact how the story is told. If you are working on a long-term project, you'll have time to experiment with visual approaches before you settle on the best one. Once you have determined the best approach, be intentional.

Not all long-term projects need to be profound. What do you have access to in your area? What stories could you tell? Do those stories require a long-term commitment? Ask these questions before you begin.

top, center, and bottom. **Here are three images from an ongoing project documenting Detroit storefront churches. I've spent a great deal of time traversing the Detroit metropolitan area searching for these unusual buildings.**

15. Travelogues

No travel stories are published without images—the mass appeal of travel stories relies largely on the photographs. Each image is an invitation to adventure and discovery. The perfect travel photo seduces the viewer.

Most travel photography is shot outdoors, primarily utilizing natural lighting to set the mood. When used editorially, it is often directly or indirectly selling something.

When shooting travel photos, consider whether this single picture could convince readers to travel to the location. If the answer is yes, then you're on the right track.

this page. **Travel photography should seduce viewers and make them want to explore the location.**

left and right. **These images were taken on the Yucatan Peninsula in Mexico. They show a little bit of Mexican history, culture, art, and travel, without being voyeuristic.**

One of the appeals of travel photography is the opportunity for the viewer to discover places they've never been and recall places they'd love to return to. The secret to photographing a well-trodden place is to find new ways to shoot recognizable landmarks and entice the viewer. Even if they've seen pictures of the Statue of Liberty before, for example, have they seen images of the statue being cleaned? Is there a new angle you could explore? What vantage points will provide fresh perspectives?

Create a loose shot list before you go; it will help to keep you on track. Shoot at different times of day. The French Quarter of New Orleans, for example, looks very different at midnight than it does at noon, and attracts different people at different times. Contact tourism boards to see if they can get you access to sites before the crowds arrive, or interviews, or help with arrangements.

Do your research before you leave *and* upon arrival. Also, ask locals for insider tips. Tour guides, hotel staff, baristas, bartenders, waiters, shopkeeeepers, etc., can provide a very different set of recommendations than you might find in guidebooks or online resources.

When traveling to faraway places, consider multiple stories you could tell (and sell), and shoot those themes. Stories and images of the people who live and work in many tourist destinations can be just as engaging as those that highlight local attractions. While travel photography's intent is often to romanticize a specific locale, the cultural context of these experiences can enrich a viewer's understanding of a place.

Pro tip: Food photography is a beloved staple of any travelogue. People want to know what you ate in the shadow of the Eiffel Tower or along the banks of the Nile!

16. The Photo Essay

The iPhone is perhaps the best tool available to bring a modern photo essay to life. As everyone is taking photos on their phones constantly, a photojournalist can go fairly undetected. Sharing images on your iPhone with an editor or on social media is near instant. Speed can be especially important for photojournalists.

A photo essay is a series of photos that build interest, evoke emotion, and tell a story. Photo essays provide a glimpse at the activities of a group of people, or information about an event or thing. Composed almost entirely of photos with captions, a photo essay contains minimal supporting text or is devoid of it altogether. The images lead the narrative so that a written story isn't required.

The photo essay on this page spread, shot on the iPhone 12 Pro, provides a behind-the-scenes look at a dog show. The preparation required to get a show dog to the ring is tremendous. These images offer glimpses of this world.

following page, top left. Grooming is an important part of preparing for judging.

center left. Handlers wait for their turn in the ring, with a third handler's foot peeking into the right side of the frame, indicating she is waiting, too. In the lower-left corner, a handler keeps her dog alert by playing with a water bottle. Beyond her is the first round of dogs being lined up, and the judges in the ring. Above them, you can see the perimeter of the ring. As your eye follows along the fence, you see a crowd of observers watching an event in a different ring. This candid tells the story of the events taking place and provides glimpses into the lives and work of the handlers and their dogs.

bottom left. To get show dogs to be obedient in the ring, handlers tear off small chunks of sausage to keep the pets wanting more. The arm band is an accessible, stain-free place to store the sausage.

top right. Handlers with Huskies wait for their turn.

center right. A handler makes eye contact with her Cavalier King Charles Spaniel.

bottom right. Handlers position their dogs for judging.

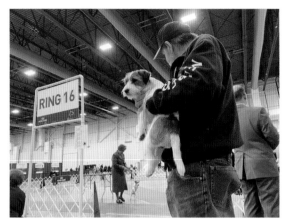

17. Elements of Humor

News is meant to be objective, and the subject matter of much reportage can often be a bit mundane. This can make it difficult to capture images that are captivating, while still illustrating the story. Look for oddities, elements of spontaneity, jarring juxtapositions, and images rendered funny by timing and framing.

Once you begin to recognize these moments of irony and humor as iPhone photography gold, you will begin to see more of these comedic moments in the world around you.

this page. **Look for moments and situations that will bring a smile to others' faces.**

above. In capturing the New York Aquarium's recent expansion, which included a shark tank, I chose to frame this image to make it appear as if the sharks were sneaking up on a man walking along the Coney Island boardwalk. This photograph tells the story, while adding an unexpected element of humor.

18. Shooting Challenges

Children & Animals

Comedian and actor W. C. Fields famously advised, "Never work with animals or children." He was referring to two pitfalls here: children and animals can steal the show with their cuteness, and they are unpredictable, making them hard to control. The latter can also be a challenge when photographing them with an iPhone. Fortunately, the framing of reportage doesn't have to be precise or stylized, as it should be in family portraiture.

Try capturing some shots from the subject's level. It will feel less threatening to them. Since kids and animals often move quickly, take more frames than usual to ensure you get the shot you need, or use Burst mode.

Do not touch a pet without permission from the owner; not all are friendly to strangers. If photographing animals in captivity, do not put your camera over the railing or stick your hands over or between bars.

When photographing kids, get in and out quickly. The novelty will wear off, and kids can become shy and fussy.

"Try taking some shots at the subject's level. It will feel less threatening to them."

top. Kids are often on the move. Use a fast shutter speed when necessary to prevent blur.

left. This dog parade was worth capturing. It tells a story and brings a smile, too.

Photographing Wildlife

Photographing wildlife can be challenging. The only real control you will have will be the camera settings. You won't have the chance to stage wild animals or alter their environment. Like pets, they are unpredictable and usually uninterested in engaging.

Pro tip: Use a fast shutter speed to help ensure clear focus for fast motion, or consider using the Burst mode.

When photographing wildlife, do not put them—or yourself—in danger, and leave no trace. Unless working directly with scientists or park rangers, avoid getting too close, as this could startle the subjects and alter their behavior. In fact, in many cases, it is illegal.

Do not handle wildlife; let the professionals do the handling. Do not wander unguided on your own into restricted areas. These areas are often off limits

for safety or conservation reasons, like delicate plant growth. Have patience. Wildlife photography requires a significant amount of waiting.

The iPhone isn't the best camera to bring on a safari due to the limits in the zoom range; however, its compact and weather-sealed build does give it a leg up on DSLRs, which are susceptible to dust and other environmental elements that can get in lenses and damage the camera sensor.

Pro tip: Consider your surroundings and wear terrain-appropriate shoes and clothing. Failing to dress appropriately for assignments in a rain forest, desert, or other extreme climate could inhibit your ability to complete the work, and is potentially dangerous.

Moving Vehicles

When shooting oncoming road traffic as a pedestrian, avoid any urge to move too close to traffic.

Remember that longer exposures result in blurred shots, and faster exposures freeze the action.

A horizontal orientation is best for photographing oncoming vehicles or shooting from a vehicle.

below. When shooting on a boat in moving water, the horizon line might rock, so steady yourself and adjust your composition accordingly. Practice water safety. A lanyard and waterproof pouch can help prevent phone loss.

above. **Lock the focus on your iPhone when shooting a moving vehicle or on a moving vehicle.**

Avoid the urge to photograph while driving. Using a phone while driving is illegal in many states and is reckless.

If photographing aerial shots from the window of a helicopter or small plane, wear a lanyard or use another method to secure your device and prevent phone loss. The wind pressure at high altitudes from a fast-moving aircraft is intense and can easily whip a phone into the air. Wear fingerless gloves to shield your hands from the chilly air. If using an attached lens, don't use a clip-on style lens, as it will easily blow off. Instead, use a lens that screws into the phone case.

> ### "Don't use a clip-on style lens, as it will easily blow off. Instead, use a lens that screws into the phone case."

19. Editing

In-App

As I mentioned earlier in this book, major edits to photojournalists' images are not encouraged or permitted by many publications. While you won't be able to remove or add people to images used editorially, minor edits such as color correction or lens correction are industry standard.

Photo-editing apps are plentiful. It can be challenging to decide which one to download and regularly use. You might prefer to upload your images using the Adobe Lightroom app and edit in Lightroom or with Adobe Photoshop on your computer. Try out the free apps before you download a bunch of apps you may not use, since many of the more robust photo apps aren't free.

Shooting images directly in the app you'll use to edit them can often create stronger results and a better user experience. All-in-one photo apps for shooting and editing include Snapspeed and ProCam. Other apps were created to integrate with each other, as is the case with Moment and Darkroom. You can shoot in the Moment app, then open Darkroom, and the app will access Moment's image library. Unfortunately, neither app is free; you will need to buy both.

Batch Editing & Presets

Shooting for publications requires working on a deadline. One way to save time in postproduction is to batch edit. Batch editing allows you to create a set

left. The original image of the egret is well composed, but the colors are a bit dull. On the following page, you will see edits made using a variety of apps. Note that a single adjustment (e.g., color, contrast) in any one app may look different than the same correction type made in a different app.

left. Here is the image edited in Lomograph. I used the Malina filter, which changed the color and created a slight blurring effect.

right. This image was edited in Photo Editor. I used the filter and gradient edit tools.

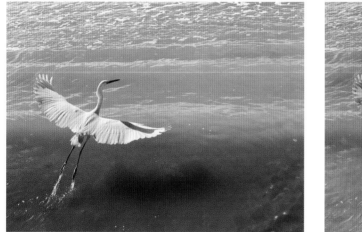
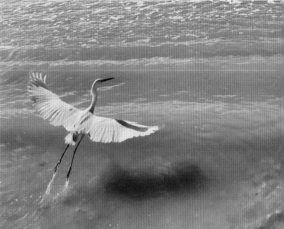

left. This image was edited in Lightroom. The temperature setting was +3, Texture +16, Clarity +15, and Contrast +5.

right. This image was edited in VSCO. I adjusted contrast, exposure, and saturation.

right. This image was edited in Darkroom. I increased the shadows, temperature, and made a Curves edit.

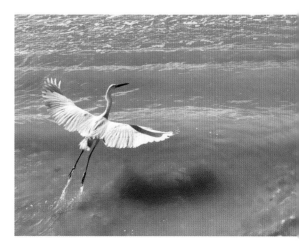

of edits, save them, then apply the edits to a series of images at once. Batch editing is a less-common app feature, but it is possible in apps like Darkroom and Adobe Lightroom.

Another option for saving time is to use a preset. A preset can be applied before or after taking the image, depending on the app. If applied after the photograph is taken, the preset works more like a filter. There are even apps, like FLTR, that consist of a collection of presets. You can also purchase presets on platforms like Etsy.

To batch edit in the Adobe Lightroom app, use the following steps:

• First, make the edits, then click on the three-dot icon in the top-right corner.
• Select Copy Settings, which will copy the settings to the clipboard.
• Next, exit out of the image, go into your image library, and select the images you want to batch edit.
• Press Paste.

It may take a couple seconds to apply all of the edits to your selection.

After the batch edit is complete, the images in the grid will all have the same edits and should look similar.

"Another option for saving time is to use a preset. A preset can be applied before or after taking the image, depending on the app."

following page. **Adobe Lightroom screenshots. This series of images will help you navigate the batch-edit process.**

20. Accessories

A billion-dollar industry has risen around accessories created for phone cameras, proving that many people are not content with the camera features on their phones and are willing to invest in additional gear to improve their images.

In the section on video, tripods were strongly encouraged for stabilization. Tripods, monopods, Gorilla pods (or other flexible tripods), and gimbals are also effective tools for shooting stills. If using a flat surface to place your phone on, use the iPhone's Level feature (now located in the Measure app) to ensure the phone is on a level surface. A selfie stick can be a legitimate tool for getting higher angles, but they can still be useful when they are not pointed at you. They can also lend stability. In fact, these camera supports are among the most popular phone camera accessories on the market.

Lenses

Accessory lenses for smartphones have come a long way from the first generation of cheap plastic lenses, which suctioned or clipped on and were little more than novelty items. High-quality glass lenses are now being produced by companies like Olloclip, Moment, and Hit Case. There is even the Insta360 Nano and Insta360 ONE, 360-degree cameras that connect to the iPhone and take 360-degree video using two fisheye lenses and stitching. The camera produces an image that is best enjoyed using a VR headset.

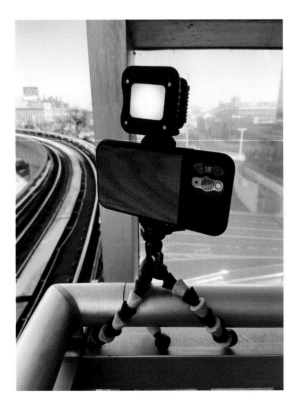

left. **A tripod is an important accessory for all serious photojournalists. There are many scenarios when having added stability will greatly improve the quality of your images.**

right. The Moment macro lens.

below left and right. The image of the full fireplace was shot with the iPhone telephoto lens, and the close-up of the fire was shot using Moment's telephoto lens. Taken from the same vantage point, these images demonstrate the significant difference that can be achieved using an external lens. Though these external lenses aren't yet as strong as external mirrorless or DSLR lenses, they are a powerful asset.

There are three main styles of lens attachments available from the premiere brands: a case that has a lens permanently mounted to it, clip-on lenses, and lenses that screw into special phone cases. Luckily, iPhone compatible external lenses cost much less than a comparable-quality traditional camera lens.

Currently, all the premium lenses are prime (fixed) lenses, without optical zoom capabilities. The top lens companies have begun developing glass filters, such as neutral density filters and polarizing filters, which add a dynamic range to the lens and elevate the overall quality.

"The premium lenses are prime (fixed) lenses, without optical zoom capabilities."

this page. The Ultimate Lens Hood in use (left). The image with the reflection (top right) was made without the lens hood. The photo below it shows the same shot made with the lens hood. All external reflections and the majority of glare were eliminated.

Lens Hoods

Lens hoods are often included with the purchase of accessory lenses, and can also be purchased separately. Most traditional lens hoods are opaque black. However, Moment takes a slightly different approach, producing clear-plastic lens hoods. This doesn't block out light as effectively, but it does limit lens flare.

If you are a photographer who shoots many images through windows from inside or outside buildings or vehicles, the Ultimate Lens Hood is the perfect addition to your kit. It is a black, malleable silicone hood attachment that hooks onto your iPhone. When pressed against a window, the lens hood eliminates all glare for clearer shots.

Shutter Release

Pressing down on the shutter button can cause camera shake, even when your iPhone is secured on a tripod. To avoid this, many photographers use the timer feature. For longer shutter speeds and greater control, shutter releases are a good option. They are useful when the camera is set up and you are some distance from it.

The easiest and most affordable remote shutter release is the wired iPhone earbuds packaged with the iPhone. Primarily used for music, the volume control button can be used to release the shutter. Simply connect the headphones, open your preferred

"For longer shutter speeds and greater control, shutter releases are a good option."

camera app and, when ready to take an image, press the + button. An added bonus of using this feature is that it can help you capture shots undetected. A synced Apple Watch will also work as a remote shutter release.

There are some excellent wireless Bluetooth shutter releases on the market, such as Camkix Bluetooth Remote Control, Kobra Tech Shutter Remote Control, and Finite Bluetooth Shutter Remote Control.

right. **The ear buds that were packaged with your iPhone can be used as a shutter release.**

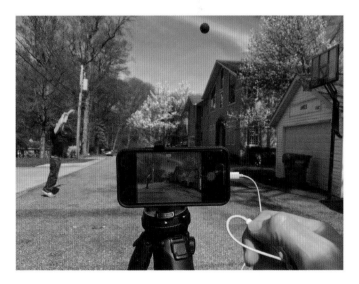

21. Code of Ethics

Journalists must abide by a code of ethics. These rules, available in slightly different versions from various sources, are easily available online.

The National Press Photographers Association (NPPA) has what many consider the most comprehensive and well-respected code of ethics, detailed in this section. To read more about the association's ethics, go to https://nppa .org/code-ethics.

1. *Be accurate and comprehensive in the representation of subjects.*
As a photojournalist, you must document any story your are shooting truthfully and fully. This is especially important in this age of mistrust of the media. Don't drop into a neighborhood, take a couple shots, and leave. Do your research and scope out the area. Get the proper spelling of names and ask questions.

If you arrive at a scene after the action has happened, do not stage or re-enact an event. News pictures are intended to depict real-life events, so staging them is inexcusable.

2. *Resist being manipulated by staged photo opportunities.*
Events like groundbreaking ceremonies or press conferences are often done with the media present. These are acceptable staged events, but keep an eye out for public figures who stage photo opportunities to send messages, and don't fall into their the trap. With your iPhone, you can take hundreds of images at close

this page. **Take care to adhere to the photojournalist's code of ethics while you work.**

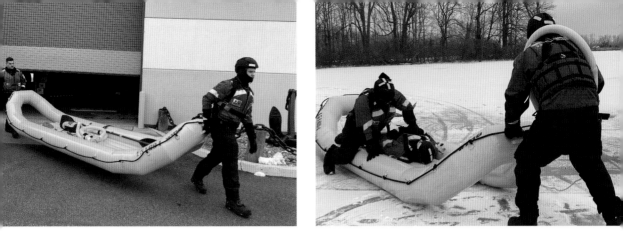

left and right. **Here are two images of a Coast Guard ice-rescue demonstration. In the first image, the officers are leaving their station with their gear, and in the second image, they are checking on the vitals of the "rescued" man after pulling him from safety. These images were taken at close range using the iPhone's on-camera telephoto lens.**

range. With three lens options built into the 12 Pro, there has never been a better time to shoot public events on your iPhone.

Unless you are assigned to take portraits, avoid posing subjects or staging scenes. In photojournalism, the photographer's job is to tell true stories. While there may be some leeway in composition, the photographer can only document, not modify, the scene around them.

3. *Be thorough. Provide context when photographing or recording subjects. Avoid stereotyping individuals and groups. Recognize and work to avoid presenting your own biases in the work.*

It's the photojournalist's responsibility to convey a story without taking a side. Sometimes this means covering a few opposing views. Avoid falling prey to gender, socioeconomic, or racial stereotypes. Educate yourself on the subject and issues around a story to establish foundational knowledge before you begin shooting .

When in doubt, consult your editor or someone within those demographics. Be respectful of your subjects at all times, it will help give you authority and credibility as a photographer.

4. *Treat all subjects with respect and dignity. Give special consideration to vulnerable subjects and compassion to victims of crime or tragedy. Intrude on private moments of grief only when the public has an overriding, justifiable need to see.*

If covering breaking news such as accidents, shootings, or natural disasters, be cautious when taking photos. Work quickly, and don't crowd a subject. Consider wider shots that convey the full story, along with tighter close-ups.

Be aware of the connotations of negative terms used to describe photo trends, such as "ruin porn," "poverty safari," and "white savior," and actively avoid them. Avoid photographing individuals who are

"Consider wider shots that convey the full story, along with tighter close-ups."

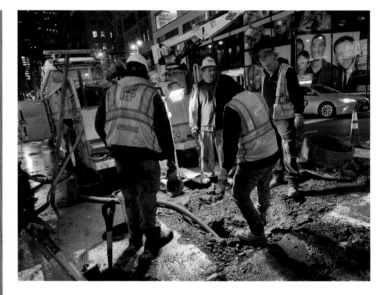

top left. Grant your subjects space and tell the story from a distance when possible, whether by shooting a wide-angle image or using a telephoto lens.

bottom left. Tell a story that differs from the standard fare and avoid common tropes to set yourself apart as a photojournalist.

above. This photo of city sewer workers on a busy New York City street was made using Night mode. I wanted to show the tireless work of municipal workers, whose efforts are often taken for granted.

homeless unless your story directly addresses the issue—the homeless are too often exploited by photographers.

There are many ways to shoot photographs at the U.S. border. Many of the images currently being captured at the U.S.–Mexico border show the migrant crisis, often depicting Mexicans as victims or criminals, depending on the perspective. This can be predatory or exploitative. There are other stories that can be told, such as news about the many families and workers who regularly cross the border without issue as part of their daily lives. Though this photograph might not be as thrilling an image, it tells a different story than the ones currently dominating headlines, and does not take away an individual's dignity.

above. Change clothes, wash your hands, and bathe as soon as possible after photographing an industrial fire or smoke. Carcinogenic smoke and chemicals can coat your clothing and skin.

5. *While photographing subjects, do not intentionally contribute to, alter, or seek to alter or influence events.* A photojournalist's goal is to document, not skew, a story. Do not tamper with evidence. Work with authorities, and do not get in their

way or make their jobs harder.

If you beat authorities to the scene of a crime or event, keep a safe distance. Take several photos to establish the scene. Tampering with evidence, even if accidental, is a punishable crime.

Be aware that you may be asked to share your images with authorities as evidence. Should this happen, direct the person making the request to your editor. It's best to have a clear understanding of your company policy regarding sharing images with the authorities.

6. *Editing should maintain the integrity of the photographic images' content and context. Do not manipulate*

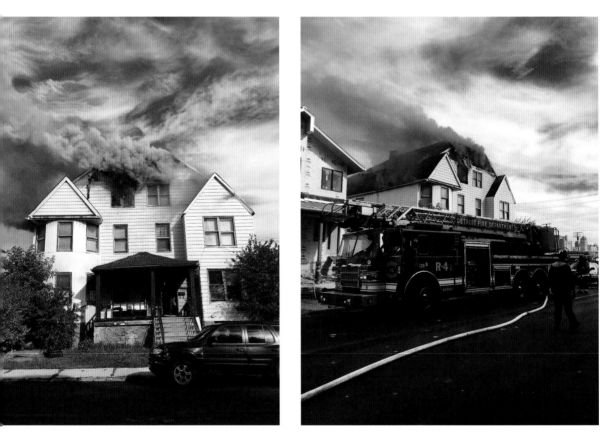

this page. I was present when a house burst into flames and was able to capture several images on my iPhone before the fire truck arrived. I maintained my position across the street, close, but not in the way, when the firemen arrived. I shot a combination of photos and video of the scene.

After I left, but before the firemen left the scene, I sent the photos and footage to four local news stations for broadcast on the evening news. With the images already on my phone, it was easy to send them in quick emails.

images or add or alter sound in any way that can mislead viewers or misrepresent subjects.

In the age of "fake news," images are being edited to show events that didn't happen in order to influence viewers and create controversy. These photos could be considered libel and grounds for legal action. Misinformation has caused a great distrust of the press. Do everything you can to avoid sharing these images or contributing to the spread of misinformation.

The photojournalist's job is to document an event, even when shooting conditions aren't ideal. It can be hard to get the shot every time, but don't take two images and alter them into a single perfect image composition. This is misleading. A handful of career photographers have made this mistake, and when caught, lost their jobs and credibility.

7. *Do not pay sources or subjects or reward them materially for information or participation.*

Paying or bribing people to get information is unethical and illegal. Blackmail, extortion, and coercion all fall under this rule.

These acts frequently result in spreading misinformation or lead to information that can't be printed

above. **Be impartial when telling a story.**

because it cannot be validated. If a source asks you to reimburse them for mailing a thumb drive or printed documents, however, it is not considered bribery.

If working in a developing country you may, on occasion, be asked to pay for information, for leads, or for contacts. Do not do so. Aside from being immoral, this behavior can be dangerous.

8. *Do not accept gifts, favors, or compensation from those who might seek to influence coverage.*

It's impossible to be impartial when

top. **Never pay or materially reward a subject for information.**

bottom. **Be creative in telling the story. Some close-ups can more effectively tell a story than a wider shot will.**

accepting gifts from someone. The temptation to accept these gifts can be great, but think of them as bribes and avoid accepting them. People will pay a lot of money for good publicity and may be willing to pay even more to avoid bad publicity.

It's standard practice for companies marketing their products to send samples to journalists. From books, to wine, to electronics, companies budget to have a number of their products sent to key publications in the hopes that someone will write a product review. For unsolicited products, journalists are not required to do so.

9. *Do not intentionally sabotage the efforts of other journalists.*
You will sometimes work with a team of people when telling a story. Work closely with the writer, editor, producer, or crew. At a large media event or breaking news event, other journalists will be present. While working, do not think of other journalists as competition, block their shots, give them false information, or sabotage their efforts. One such move could destroy your reputation and harm other journalists.

In some cases, you may find yourself working with undercover journalists or undercover detectives. Do not expose them or compromise their identity in any way, as this could put you both of you in danger.

Be a team player. If there are other photographers on the scene, note where they are working, and try not to obstruct their shots. Offer

tips if you arrive earlier, and listen to advice they have—they may offer to share contacts, angles, or thoughts on areas to avoid.

10. *Do not engage when harassed by colleagues, subordinates, or subjects. Maintain the highest standards of behavior in all professional interactions.*

Being respectful and courteous goes a long way, as does the ability to take or ignore criticism.

In the new media landscape, journalists and photographers are now required not only to deliver quality work in understaffed and underpaid conditions, but also to have an active social media presence. Some can even fast track their careers by developing a public persona that engages a large social following. Trolling aims to provoke otherwise reasonable people to lose their tempers online. Sometimes your own colleagues will question or criticize your work. Listen to constructive feedback, but ignore negative noise. Take the high road. If you are the subject of online bullying, take screenshots as evidence, as Tweets and posts can easily be deleted.

top. **When working with other journalists, respect their space and act respectfully toward them.**

bottom. **When documenting restricted areas, stay in approved areas unless given clearance.**

22. Best Practices

Be Prepared

Photojournalism exists to tell a story better than the text that surrounds it. Your images should directly support the text and illustrate the story. Therefore, it is important to understand the assignment and the possible directions the story could go.

Come with a clear understanding of the issues and ways to develop the visual side of the story.

Avoiding Bias

Work against your own biases. Aim to tell a balanced story when possible; do not let your opinions taint the facts. Opinion pieces, reviews, and news stories are meant to be free from bias, although in today's media landscape, many companies thrive because they extol a point of view. Personal stories are an exception.

The angle used to capture a subject can show them as powerful or weak, as can the lighting. For example, a photograph taken at a low angle of a person can make them look heroic, while uplighting on a subject's face brings out every wrinkle and dimple. Unflattering or overly flattering images of public figures can be damaging or reaffirming. Try to be fair to all subjects, and let the writers define the story. Determine whether your shot leans into your personal bias, and adjust accordingly. Shoot from a variety of angles, and remember there are many ways to illustrate the story. For example, you could take a wide-angle shot of many photographers shooting a press conference, with the speakers in the background rather than in the foreground.

left and right. **Seek to tell the whole story with your images.**

above. **Social media is a great resource for learning about events scheduled in your community.**

Shooting on a Deadline

Navigating tight deadlines can be a challenge, as it can often take time to identify subjects, gain their trust, and secure the access needed to shoot a compelling photo essay.

Before beginning any assignment, get to know your gear inside out. In the past, photojournalists wouldn't dream of starting an assignment without a DSLR camera, a couple of lenses, and a flash. Now, many photojournalists use their iPhones interchangeably with their traditional cameras. Practice using the newest iPhone apps—you can do so just about anywhere, and it will help you work more efficiently.

Keep to a schedule and manage time wisely. Check in with your editor regularly. If you are up against a deadline, edit some of your images as you go, and send them to your editor. Even if you haven't completed final edits, this can help your editor lay the page out and select the best shots while waiting for the final product.

Check in with your editor regularly. If up against a deadline, edit some of your images as you go and send them to your editor. Even if you haven't completed the final edits, this can help your editor lay the page out and select the best shots while waiting for the final product.

If you are away on assignment, emailing photos or uploading them to the company's digital asset management system is often the best way to share your work quickly. If using a company iPhone with access to Wi-Fi, you can also share your iCloud user account and password with your editor for fast image transfers while in the field.

Current Events

Photojournalists document current newsworthy events, local events, and human interest stories. Images more than a month old, unless used in long-form essays, aren't considered current editorial images, with a couple exceptions: city skylines or shots of a city's atmosphere might be deemed evergreen images, which are viable for editorial use. These local images can be used between stories and don't always need to be associated with a story. Travel photography can also be delayed, as often travel writers submit their stories weeks after they return from trips.

below. **This diner employee wearing a government-mandated mask during the COVID-19 outbreak elevates an otherwise mundane scene into a poignant image of a time and place. In time, photos documenting the pandemic may become iconic. This was taken with a Moment telephoto lens.**

Agencies & Stock Companies

A handful of agencies and stock companies specialize in representing amateur and professional photographers and videographers whose preferred camera is their iPhone. Apps like Stockimo and EyeEM make it easy to submit your image, right through the app itself.

The benefit of working with agencies is that your images will likely be seen by more media outlets. Producing stock can be a way to make money from an

this page. **Look for photo opportunities wherever you go. It is not only a chance to practice your craft; shooting stock can also make you money.**

left and right. **Photographers who develop an original look in their stock collections are more successful than those who have a mix of images.**

image you have taken, or plan to take. Also, these agencies manage payment, so you don't need to send out any invoices.

Each agency has a different submission policy, readily available on their website. If you choose to work with an agency, read their licensing terms, rates, crediting, and conditions carefully. Agencies differ on copyright.

Pro tip: Believe it or not, pictures taken of iPhone bodies or people using their iPhones are lucrative stock photos. You don't have to travel somewhere exotic or dine at an experimental restaurant to capture winning stock photos. You can simply take photos of your friends using their iPhone, or take some photos of your own.

If photographing stock is something that interests you, seek out visually interesting spaces. These images would be considered evergreen and creative, rather than editorial-only stock. This type of image has a longer shelf life because it is not bound to a specific time frame. Look to shoot a mixture of evergreen and seasonal images.

Many photojournalists supplement their income with successful stock businesses. When contributing stock, find a niche, whether it is editorial news or evergreen photos, and submit that style of image. When there is consistency in your image collection, it is easier for users and generates more purchases.

Editorial

Editorial photos are images of breaking news and newsworthy events. They differ from commercial photography in style and tone.

Shooting editorial images requires photographers to roll with the punches in situations they may have little control over. Producing editorial content also requires a lot of charm, as photographers are required to get great shots of subjects who are reluctant to have their photos taken as well as those who are not accustomed to working with professional photographers.

Editors have demanding schedules, so successful photojournalists must possess a distinctive vision and the ability to work with little instruction.

Avoid the tendency to shoot a few frames and move on. Look over your images and adjust your shot if you need to. Live mode can be useful for shooting editorial content if you have limited access to an event or subject.

Editorial photography can range from just you and your iPhone to large shoots with production teams, expansive sets, and lights. Even if you are using a DSLR for a large-scale shoot, your iPhone can be an invaluable tool. You can use it to get a test shot of your subject or use the rear camera so your subject can see him or herself or touch up their hair. Apps like Lumu Light Meter

top and bottom. **Live mode can be advantageous when you have a limited opportunity to shoot editorial content.**

are great tools to adjust color temperature and flash exposure on a DSLR. You can also use your iPhone to play music to calm your subject and set the mood.

Sponsored Content

In the digital media landscape, most publications produce a blend of editorial, lifestyle, and sponsored content. It's become commonplace to see listicles (writing or other content presented wholly or partly in the form of a list), roundups, and splashy product reviews

sandwiched in smaller verticals between traditional editorial news content. The use of this content can be attributed to two factors: it drives revenue and it is readily shareable content.

Product review pages, listicles, and slide shows are often sponsored content. A company will pay and/or donate products to the publication for a shot at being reviewed, or sometimes will split revenue made on ads on that page or pages. If the content is syndicated on a partner website, they will split ad-share revenue with the originating publication. This kind of content is profitable, and images are the centerpiece of these stories.

Many publications take original product photography that aligns with their company style guide rather than using brand-provided images. Flat lay images are commonly taken to accompany articles featuring beauty products or other merchandise. Traditional DSLRs can be unwieldy when shooting flat lays because they cast shadows and need a longer focal distance to focus, but iPhones are perfect for shooting flat lays. When shooting flat lays, mind your shadows.

left. **When shooting product photography on an iPhone, use Portrait mode or an app like Focos, which offers an adjustable aperture.**

left. This picture tells a story using a wide depth of field with everything in focus. In the tent behind the main subjects, vendors are selling s'more makings, and people are buying them. The two teens on the far right have finished making s'mores and are gleefully eating them.

right. This shot shows a diverse gathering of families with young children roasting marshmallows. Note the photographer in the right corner shooting, too. A lot comes together to make this image compelling. Use these shooting opportunities to make contacts in the community. People featured may want a copy of the image. Offering to email a copy to the parents is another good way to engage others and build contacts.

Digital editors demand content they think will get traffic, likes, and shares. The more shares an article has, the more eyes will see it—it's free publicity for the publication and can be a powerful marketing tool. Every journalist today is chasing the dream of their content going viral. Dazzling photos are critical to the success of this content. Some might question the journalistic quality of this content, but no one can deny its staying power within the industry.

Contacts & Networking

As a journalist, every social gathering or chance encounter can be an opportunity to network and build your contacts. When starting out on a beat, you may inherit previously vetted contacts the publication has used, but don't neglect building your own network.

Gone are the days of the traditional Rolodex, so saving digital copies of contact information is important. Start by getting the exact spelling of individual's first and last name. If you prefer to

write it down on paper, be sure to enter it into your phone contacts later. Build a robust spreadsheet on Google Sheets that can be pulled up in-app on your iPhone.

Bring business cards with you and consider getting a phone case with a built-in pocket to store them. If you are a freelance photographer, print up some of your own cards. Don't be timid to ask people for their contact informa-

tion. It can be daunting at first, but over time, it will become second nature.

Carrying a Camera

There's an old photographer's adage that still rings true: your best camera is the one you have with you.

You may not always carry around a DSLR or mirrorless camera. If you are carrying them, you might have them in your backpack with the lens stored in padded pouches, not connected to the camera body. When this happens, by the time you rifle through your bag to secure the lens and adjust the settings, the shot may be gone. You won't have this problem with your iPhone, as the new models' locked screens offer the camera button shortcut, reducing the time it takes to snap a picture to about two seconds.

There are very few situations when you won't have your iPhone with you, making it, perhaps, the best, most trust-

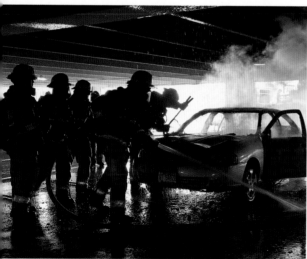

top and bottom. **I was working at an office across the street from a parking garage when a car burst into flames. Luckily, there were no cars parked near the vehicle, so I was able to stay a safe distance away and not obstruct the fire squad, while capturing silhouetted shots at close range. The Night mode setting helped me to effectively capture these moments.**

this page. **Once you begin to get published regularly, keep your CV updated and group the more prestigious publications at the top.**

ed, and most-used camera you own. With that in mind, always be prepared. There is a story waiting to be told everywhere, and events develop quickly.

As a photographer, it's your job to capture these unexpected moments. Always be on the lookout for opportunities to find the next big story. When having casual conversations, consider whether there is a larger story that's worth exploring.

Getting Published

It can be a challenge to get your first bylines when starting out in the industry. If you are lucky enough to get a staff photo job for a publication, your work will be published regularly. If you are a freelance photographer, you will have to hustle to get noticed.

Network and reach out to photo editors in your area; don't expect them to find you. Set up meetings to show them your work. Send links and mailers of your work ahead of time, and then bring paper prints or an iPad with your portfolio on it. Ask the photo editor what kinds of images they are looking for, then follow up by email the following week. Answer calls from unknown

numbers—editors might call you for an assignment, and if you miss the call, you might lose the gig!

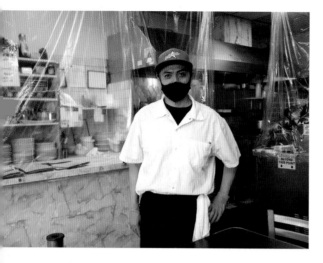

If you have a publication interested in publishing a passion project, be sure to ask about compensation ahead of time. Some of the smaller digital media companies offer low or no compensation for hosting photo slide shows. Do not take assignments "for exposure"; there is little cost benefit to doing this.

If you're unsure what to charge for an assignment there are a number of

this page. **Always seek information about payment before agreeing to have your images published.**

up-to-date online resources like Getty Images that offer industry rates and guidance on what to charge. If you must travel, consider travel costs and rental fees for gear used in the shoot, even if it's your own gear. If you must accept foreign currency for a publication abroad, add a currency exchange fee, since your bank will charge one.

Instagram

Social sharing apps can be used to build an audience for your work. Photo directors, galleries, photo organizations, and publications use them to discover and hire emerging photographers.

Instagram is today's most popular photo-sharing app. As of early 2020, there are over 1 billion users every month. The opportunities to get your work seen on Instagram are far greater than on any other image-sharing app. If you want to get more eyes on your work, you can easily promote posts or set up targeted ads.

Here are some tips to maximize your Instagram account:

- Keep the latest version of the app installed on your iPhone.
- Use your profile to describe the content in the account and add a link to your website or some way that others can contact you.

- Use targeted hashtags, but not so many it clutters up your post.
- Consider the full grid and aim for visual consistency and a strong overall composition.
- Post regularly and experiment to determine the best days and times of day to post for maximum exposure.
- Follow people and organizations that inspire you, and make an effort to engage with them on their feeds.
- Always check your grammar and spelling before posting.

"If you want to get more eyes on your work, you can easily promote posts or set up targeted ads."

- Cross-share your posts on Facebook and Twitter.
- Be sure to tag local news organizations or use their hashtags for breaking news events.
- Add stories and IGTV to your feed. Live videos are popular and can be less serious in tone. Stories had over 500 million daily viewers in early 2020, a number that continues to grow.

Pro tip: For consistency, consider using a filter preset for all images posted on Instagram.

Pro tip: Decide if you want to be present in your feed. Some journalists include themselves in photos, while others show only their professional or personal photos.

Style

Once you fully master all of the settings on your iPhone and become confident in shooting, you should work to

this page. Develop your personal style and get your work seen by regularly posting on Instagram. Doing so, and tagging news outlets when posting newsworthy images, can help you get noticed.

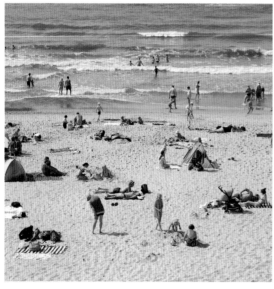

develop your personal aesthetic. Having a unique visual style will help differentiate your work. As mentioned in the introduction, there are fewer photojournalism jobs than ever, and the industry is flush with talented photographers fighting for scraps. By developing your individual style, you will make it easier for editors to identify your work when they see it and determine if you are the best photographer for an assignment.

Here are some helpful tips to consider in developing your visual style:

• Look to the trailblazers in your field for inspiration. Study their photos to determine how they got the shot.
• Practice.
• Experiment with editing apps and settings.
• Follow your gut.
• Stay abreast of industry trends.
• Consider joining a photo organization.
• Look for photography mentors within your community.

Organizations

There are a handful of reputable organizations that provide large networks, further training, legal aid, conferences, and competitions. Here are the most prominent photography organizations in the United States:

above. **An interesting way to show a tourist destination is shooting people taking selfies.**

• National Press Photographers Association (NPPA) https://nppa.org
• American Photographic Artists (APA) http://apanational.org
• Professional Photographers of America (PPA) http://www.ppa.com
• American Society of Media Professionals (ASMP) http://asmp.org
• American Photography Association (APA) http://www.apaamerica.com/

Additionally, online photography communities at the national and regional levels can provide feedback, business advice and a list of available gigs, and be a place to build your network. Facebook, in particular, has a number of regional groups. Here are some photography groups with active followings:

- A group for sharing and commenting on photographs: https://www.reddit.com/r/iPhonePhotography/
- Riot Girls of Journalism, a women-only journalism group: https://www.facebook.com/groups/1698979077092920/

- An iPhone photography group: https://www.facebook.com/groups/iPhonePhotographer/
- A network of diverse female photojournalists: https://twitter.com/womenphotograph:
- The original online photography platform still has active groups and communities: https://www.flickr.com/

What's in My Bag

Having tried and tested dozens of applications and accessories, here is what I use as part of my workflow:

below. **This photo was made with the Moment telephoto lens and the Moment app.**

I currently have two iPhones—the iPhone 12 Pro and iPhone 6—and use them both daily. While the quality improves considerably with each new model, I believe good images can be taken on any working iPhone— especially when photography fundamentals are applied.

I often use the Camera app's Portrait mode and Burst mode, as outlined in previous chapters. When I want additional control over my settings, I shoot using the ProCam and Moment apps. Both are user-friendly.

Snapspeed is my favorite general photo-editing app. I use SKRWT to alter the angle of an image, particularly architecture. Carbon is my favorite black & white app. I use Lightroom on my desktop, but not often on my iPhone.

The Peak Design Aluminum Travel Tripod is the best compact tripod I've ever used, and it is great for use for mobile and traditional cameras. Additionally, the company offers excellent warranties and customer service.

Moment Lenses are the only external lenses I use. I currently have the macro and telephoto lenses and phone case.

I use Dropbox for my Cloud-based storage and Seagate external hard drives as portable storage. I regularly back up my photos on multiple hard

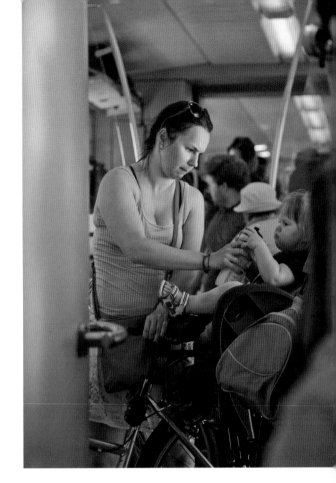

above. **Even during your daily activities, there may be interesting photo opportunities.**

drives and on Dropbox to safely save my images.

I have two Lume Cubes, which work great for both iPhone photography and supplemental lighting for my DSLR.

These are the tools I currently enjoy using the most, but what works for me might not work for you. It is a good idea to test out accessories like tripods, lenses, and gimbals before you invest in them. So, if you are able, borrow or rent them before you buy.

Conclusion

As the journalism industry continues to evolve, there may be fewer staff photography jobs, but photography is more important than ever. There will always be a need for photography in print and digital media. It could be argued that with all the online platforms and digital media startups hungry for more content, there has never been a greater need for photojournalism.

The democratization of technology has lowered the barriers to entry for aspiring photojournalists. The affordability of smartphones and the proliferation of digital platforms on which to share images have leveled the playing field. Amateur photographers have flooded the marketplace, but images produced by a photographer with a well-trained eye will still stand out from the crowd.

While social media is a great avenue for sharing art and is widely used by photographers of every skill level,

below and following page. **Use social media to share your best images and draw the attention of editors looking to find new talent.**

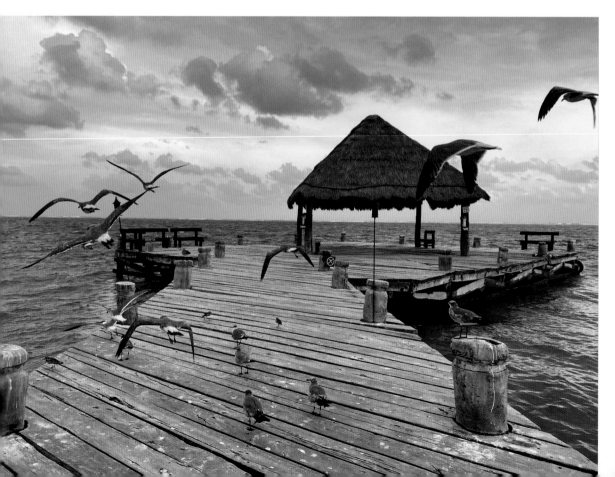

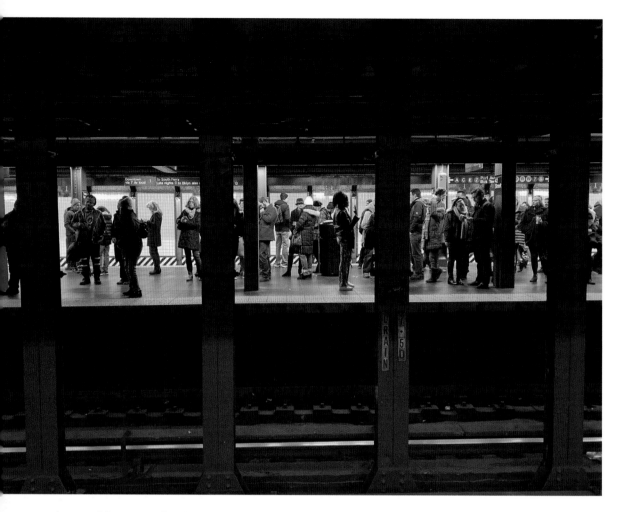

above. **You can find unexpected compositions just about anywhere—you just have to look for them.**

it's important to remember that editors often find talent online. Be intentional when selecting and sharing your content. It could very well lead to future work!

This book covered the essential principles of photojournalism, along with some advanced iPhone techniques to provide you with the skill set and mind-set to capture powerful images. Armed with the tools and knowledge to use your iPhone to its full potential, you will have a competitive edge over other photojournalists in your field.

Try out the apps listed in this book. Don't download every app at once—you'll forget why you did, and half those apps will go unused. Delete any apps you never use, as they take up valuable space on your iPhone and can be more discouraging than helpful. Group your apps into folders by theme

to make it easier to locate the one you want. When downloading apps, look at features of similar apps. There are thousands of iPhone-compatible photography apps. I've selected some of the best, but more are released and iterated on each year. Chances are, the next great photo app will be released between the time this book goes to print and the time you read this page.

With each iPhone model, new innovations and features are added, making the iPhone camera as powerful as many traditional cameras. It may soon surpass them. Stay abreast of technological changes and improvements. Experiment with apps and accessories, find what works best for you, and be on the lookout for new technologies.

It won't be long before the majority of Pulitzer Prize–winning photos are captured on smartphones. Keep taking photographs on your iPhone, and yours may soon be one of them!

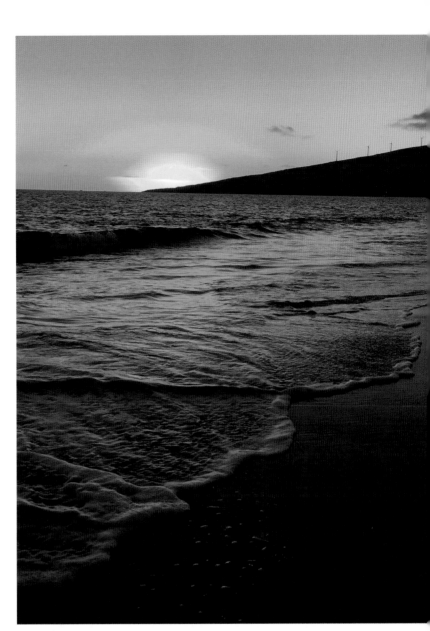

above. **Look for changing landscapes like this one. Here, the eye is drawn to the sunset along the water first, but then focuses on the windmills in the upper-right third of the background.**

Index

AmherstMedia.com

- *New books every month*
- *Books on all photography subjects and specialties*
- *Learn from leading experts in every field*
- *Buy with Amazon (amazon.com), Barnes & Noble (barnesandnoble.com), and Indiebound (indiebound.com)*
- *Follow us on social media at: facebook.com/AmherstMediaInc, twitter.com/AmherstMedia, or www.instagram.com/amherstmediaphotobooks*

Create Pro Quality Images
with Our Phone Photography for Everybody Series

iPhone Photography for Everybody
Black & White Landscape Techniques

Gary Wagner delves into the art of creating breaktaking iPhone black & white landscape photos of seascapes, trees, beaches, and more. $29.95 list, 7x10, 128p, 180 color images, ISBN 978-1-68203-432-3.

Phone Photography for Everybody
Family Portrait Techniques

Neal Urban shows you what it takes to create personality-filled, professional-quality family portraits with your phone. $29.95 list, 7x10, 128p, 180 color images, ISBN 978-1-68203-436-1.

iPhone Photography for Everybody
Artistic Techniques

Michael Fagans shows you how to expertly use your iPhone to capture the people, places, and meaningful things that color your world. $29.95 list, 7x10, 128p, 180 color images, ISBN 978-1-68203-432-3.

Phone Photography for Everybody
Still Life Techniques

Beth Alesse provides creative strategies for artfully photographing found objects, collectibles, natural elements, and more with a phone. $29.95 list, 7x10, 128p, 160 color images, ISBN 978-1-68203-444-6.

iPhone Photography for Everybody
Landscape Techniques

Barbara A. Lynch-Johnt provides all of the skills you need to master landscape photography with any iPhone. *$29.95 list, 7x10, 128p, 160 color images, ISBN 978-1-68203-440-8.*

Phone Photography for Everybody
iPhone App Techniques— Before & After

Paul J. Toussaint shows you how to transform your iPhone photos into fine art using an array of free and low-cost, simple apps. $29.95 list, 7x10, 128p, 160 color images, ISBN 978-1-68203-451-4.